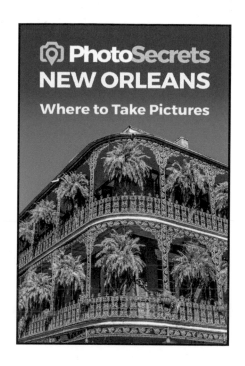

PHOTOSECRETS
NEW ORLEANS

WHERE TO TAKE PICTURES

BY
ANDREW HUDSON

T0163494

*"A good photograph
is knowing where to stand."*
— Ansel Adams

Welcome
By Andrew Hudson

THANK YOU for reading PhotoSecrets. As a fellow fan of travelling with a camera, I hope this guide will quickly get you to the best spots so you can take postcard-perfect pictures.

PhotoSecrets shows you all the best sights. Look through, see the classic shots, and use them as a departure point for your own creations. Get ideas for composition and interesting viewpoints. See what piques your interest. Know what to shoot, why it's interesting, where to stand, when to go, and how to get great photos.

Now you can spend less time researching and more time photographing.

The idea for PhotoSecrets came during a trip to Thailand, when I tried to find the exotic beach used in the James Bond movie *The Man with the Golden Gun*. None of the guidebooks I had showed the beach, so I thought a guidebook of postcard photos would be useful. Twenty-plus years later, you have this guide, and I hope you find it useful.

Take lots of photos!

Andrew Hudson

Andrew Hudson started PhotoSecrets in 1995 and has published 26 nationally-distributed color photography books. His first book won the Benjamin Franklin Award for Best First Book and his second won the Grand Prize in the National Self-Published Book Awards.

Andrew has photographed assignments for *Macy's*, *Men's Health* and *Seventeen*, and was a location scout for *Nikon*. His photos and articles have appeared in *National Geographic Traveler*, *Alaska Airlines*, *Shutterbug*, *Where Magazine*, and *Woman's World*.

Born in England, Andrew has a degree in Computer Engineering from the University of Manchester and was previously a telecom and videoconferencing engineer. Andrew and his wife Jennie live with their two kids and two chocolate Labs in San Diego, California.

☕ Contents

Morning

Afternoon

Dusk

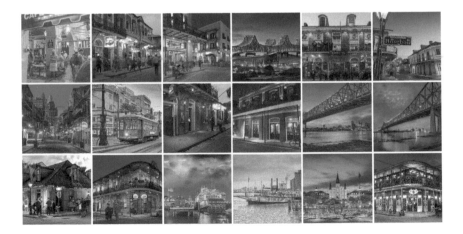

Night

Indoors

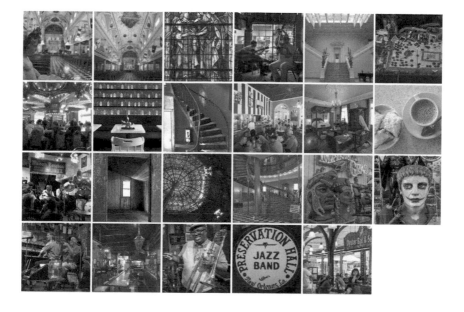

📍 New Orleans

New Orleans is a port city in Louisiana, on the Mississippi River by the Gulf Mexico. Nearby are swamps and plantations, and the state capital of Baton Rouge.

📍 French Quarter > Central

Central French Quarter is the heart of New Orleans, founded in 1718 by French colonists. The central Bourbon Street is the first destination for many tourists, with its Mardis Gras bars, Creole jazz music, and romantic colonial architecture.

Upper French Quarter is the southwest section ("upper" meaning upstream on the Mississippi River), from Iberville to Orleans, blocks 200-720. Elegant restaurants and hotels surround Royal Street.

📍 French Quarter > Lower

Lower French Quarter is the northeast section, from Orleans to Esplanade, blocks 720–1400. Horse-drawn carriages pass brick buildings decorated with lace-like iron galleries and hanging plants.

Jackson Square is the historic center of New Orleans and includes a French cathedral and a famous beignet-serving coffee-shop.

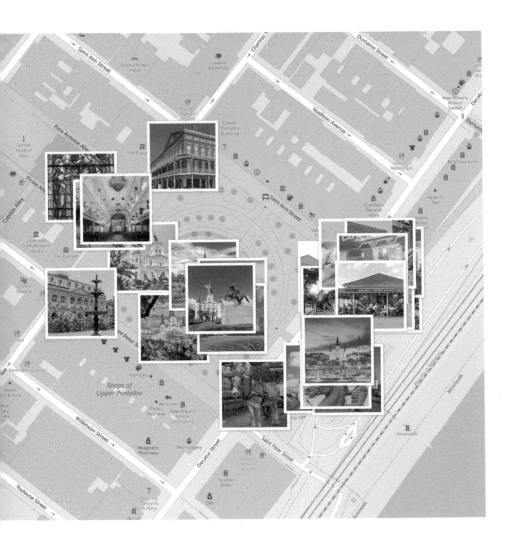

📍 French Quarter > Riverfront

Riverfront French Quarter lines the east and southeast edge along Mississippi River, with paddle-wheelers and an aquarium.

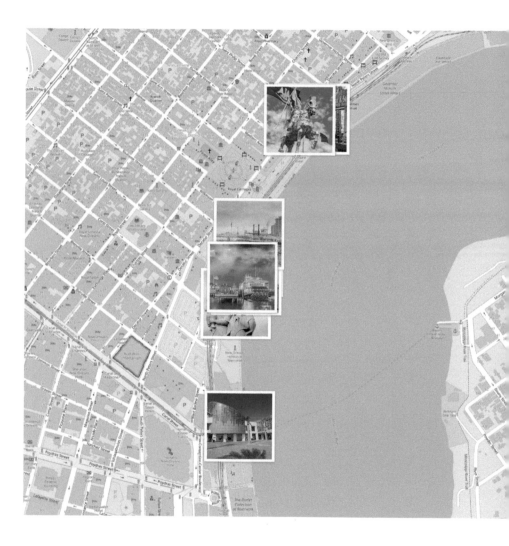

◉ Central New Orleans

Central New Orleans is the city center outside the French Quarter, and includes the Central Business District, Lower Garden District, Marigny, and the Mid-City Area.

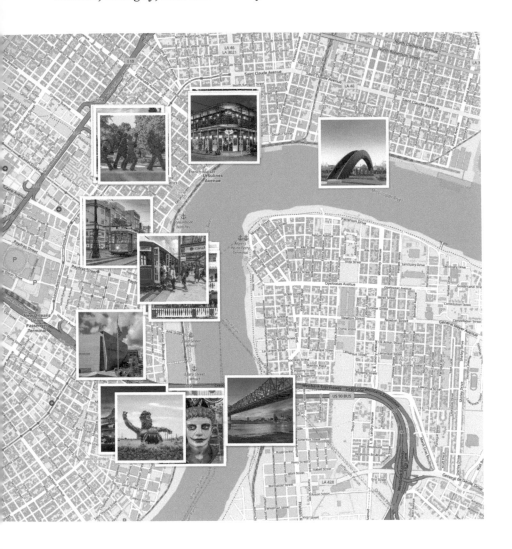

📍 Uptown New Orleans

Uptown New Orleans is the area west and north of the French Quarter and the city center, between the Mississippi River and Lake Pontchartrain.

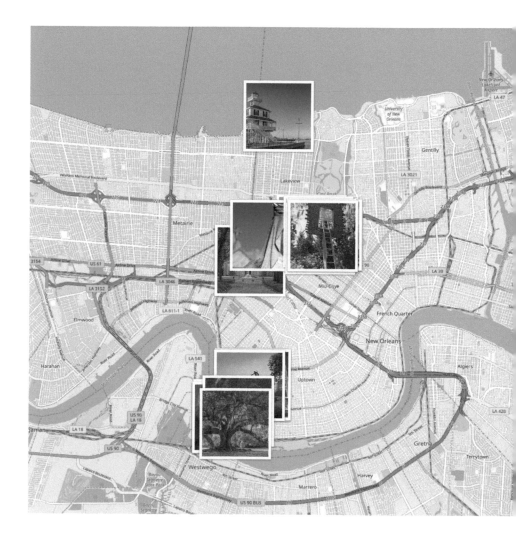

📍 Metro New Orleans

Metro New Orleans, or the Greater New Orleans Region, encompasses eight parishes in southeastern Louisiana, around New Orleans and Lake Pontchartrain.

A GREAT TRAVEL photograph, like a great news photograph, requires you to be in the right place at the right time to capture that special moment. Professional photographers have a short-hand phrase for this: "F8 and be there."

There are countless books that can help you with photographic technique, the "F8" portion of that equation. But until now, there's been little help for the other, more critical portion of that equation, the "be there" part.

To find the right spot, you had to expend lots of time and shoe leather to research the area, walk around, track down every potential viewpoint, see what works, and essentially re-invent the wheel.

In my career as a professional travel photographer, well over half my time on location is spent seeking out the good angles. Andrew Hudson's PhotoSecrets does all that legwork for you, so you can spend your time photographing instead of wandering about. It's like having a professional location scout in your camera bag. I wish I had one of these books for every city I photograph on assignment.

PhotoSecrets can help you capture the most beautiful sights with a minimum of hassle and a maximum of enjoyment. So grab your camera, find your favorite PhotoSecrets spots, and "be there!"

Bob Krist

Bob Krist has photographed assignments for *National Geographic, National Geographic Traveler, Travel/Holiday, Smithsonian,* and *Islands.* He won "Travel photographer of the Year" from the Society of American Travel Writers in 1994, 2007, and 2008 and today shoots video as a Sony Artisan Of Imagery.

For *National Geographic,* Bob has led round-the-world tours and a traveling lecture series. His book *In Tuscany* with Frances Mayes spent a month on *The New York Times'* bestseller list and his how-to book *Spirit of Place* was hailed by *American Photographer* magazine as "the best book about travel photography."

After training at the American Conservatory Theater, Bob was a theater actor in Europe and a newspaper photographer in his native New Jersey. The parents of three sons, Bob and his wife Peggy live in New Hope, Pennsylvania.

ⓘ Introduction

New Orleans beckons your camera with romantic buildings and colorful culture.

As the ocean port of the Mississipi River, which drains about 40% of the U.S., New Orleans is the economic and commercial hub for the broader Gulf Coast region.

Founded in 1718 by French colonists, the city was named for the Duke of Orléans, Philippe II, who was Regent of the Kingdom of France at the time. Following France's defeat by Great Britain in the Seven Years' War, the colony was ceded to the Spanish Empire in 1763. Nearly all of the surviving 18th-century architecture of the French Quarter (Vieux Carré) dates from the Spanish period. After a brief return to French control, Napoleon sold Louisiana (New France) to the United States in the Louisiana Purchase in 1803.

In 1840, New Orleans was the third-most populous city in the United States, and it was the largest city in the American South from the Antebellum era until after World War II.

Major commodity crops of sugar and cotton were cultivated with slave labor on nearby large plantations. Dwarfing the other cities in the antebellum South, New Orleans had the nation's largest slave market. The market expanded after the U.S. ended the international trade in 1808. Two-thirds of the more than one million slaves brought to the Deep South arrived via forced migration in the domestic slave trade.

Today, tourism is the top economic sector as measured by employment and wherever you go, you'll be glad you brought your camera to New Orleans.

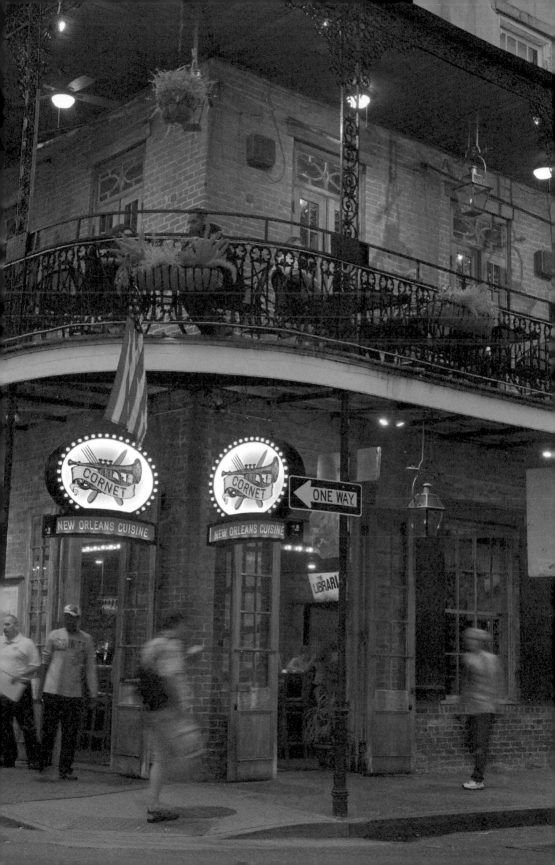

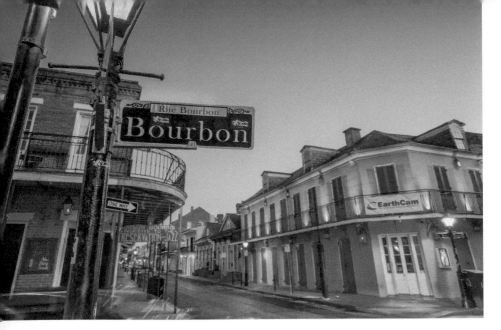

Bourbon Street is the heart of New Orleans, and the city's main tourist attraction. Bars, bands, and beads line the center of the French Quarter where Mardi Gras is celebrated every night. The party starts on Bourbon Street at St. Louis Street for three blocks to Orleans Street, and a block down St. Peter Street to Royal Street.

The **French Quarter** (in French, the **Vieux Carré** meaning Old Square) is the oldest neighborhood in New Orleans, founded in 1718 around a central square. The French colonial buildings were mostly destroyed by fires in 1788 and 1794, so today's quaint historic buildings date to the late 18th century, during Spanish rule. They features fire-resistant stucco and elaborately decorated ironwork balconies and galleries.

✉ **Addr:**	Bourbon St, New Orleans LA 70130	♀ **Where:**	29.957142 -90.0669955
❷ **What:**	Street	◑ **When:**	Anytime
👁 **Look:**	Southwest	W **Wik:**	Bourbon_Street

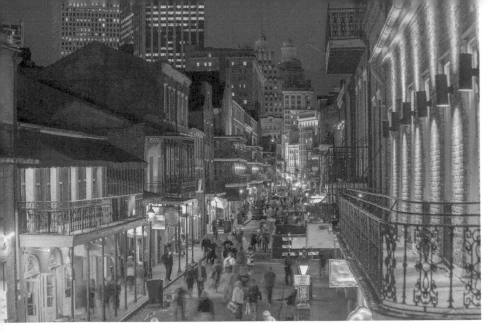

Bourbon Street from the balcony at Big Easy Daiquiris.

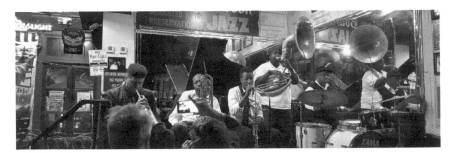

Above: Maison Bourbon at 641 Bourbon St. Below: View from 511 Bourbon St.

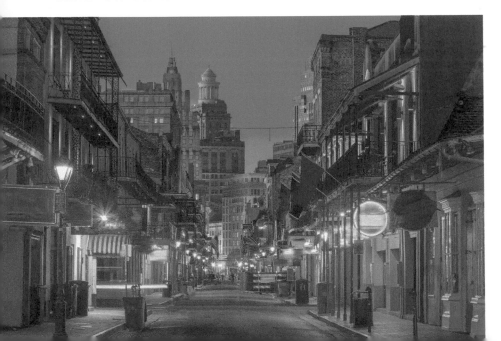

Above: 526 Bourbon Street. Below 711 and 700 Bourbon Street at St. Peter.

 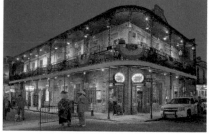

Below: Street band at 718 Bourbon Street.

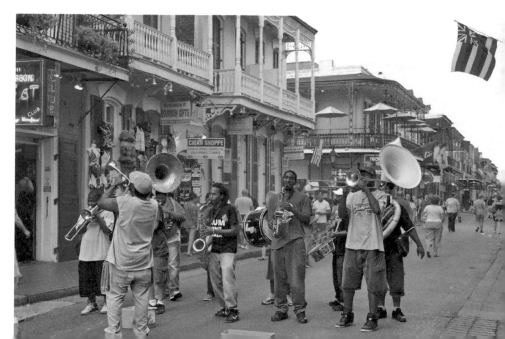

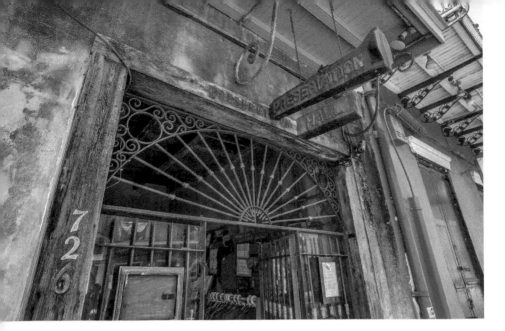

Preservation Hall is New Orlean's most famous jazz venue, noted for its touring house band, motley exterior and absence of alcohol. Built in 1817 as a classic Creole style house, and changed little since, the venue grew in prominence when Allan and Sandra Jaffe visited on their honeymoon in 1961 and stayed to support local musicians.

✉ **Addr:**	726 St Peter, New Orleans LA 70116	♀ **Where:**	29.958355 -90.065344
❓ **What:**	Jazz venue	☽ **When:**	Morning
👁 **Look:**	West-southwest	W **Wik:**	Preservation_Hall

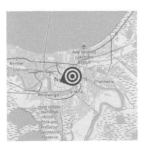

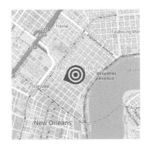

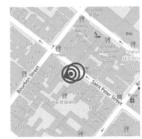

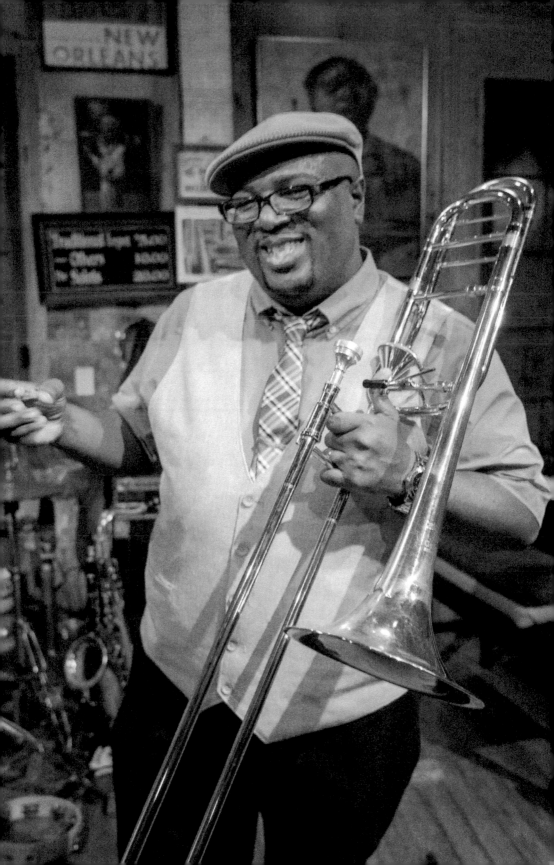

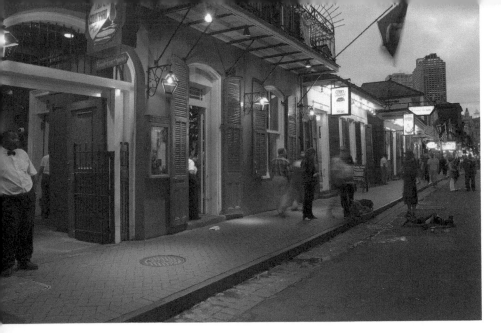

Pat O'Brien's Bar is the most famous bar in New Orleans. In a building dating from 1791, the city's signature hurricane drink was invented here in the 1940s, when surplus rum was combined with passion fruit syrup and served in a glass shaped like a hurricane lamp.

✉ **Addr:**	734 St Peter, New Orleans LA 70116	♀ **Where:**	29.958261 -90.0651754
❓ **What:**	Bar	◑ **When:**	Morning
👁 **Look:**	West-southwest	W **Wik:**	Pat_O%27Brien%27s_Bar

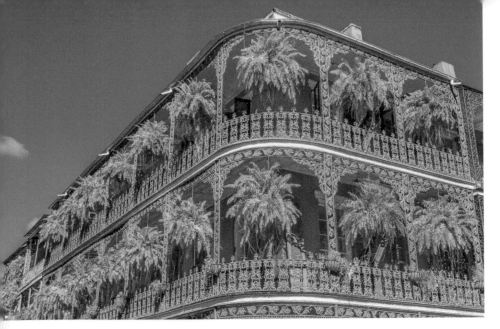

LaBranche House is the quintessential French Quarter sight, and probably the most photographed house in New Orleans. A delicate, lace-like pattern of silver ironwork lines the upper two galleries, accented by hanging Boston Ferns, and white windows with green shutters on red-painted brick.

The family name was reputedly born in 1737, when emigrant Johann Zweig said his name meant 'twig' in German, and the French notary replied "Oui, la branche!" The renamed Jean Baptiste LaBranche became a wealthy sugar planter and his widow, Madame Melasie Trepagnier, constructed this architectural treasure in 1837–1840 as one of a group of eleven buildings. Look close and you'll see the cast-iron design includes oak leaves and acorns.

✉ **Addr:**	700 Royal St, New Orleans LA 70116	⚲ **Where:**	29.957986 -90.064831
❓ **What:**	Area	◑ **When:**	Anytime
👁 **Look:**	East-northeast	↔ **Far:**	18 m (59 feet)

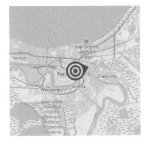
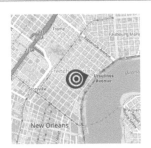
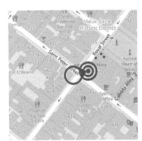

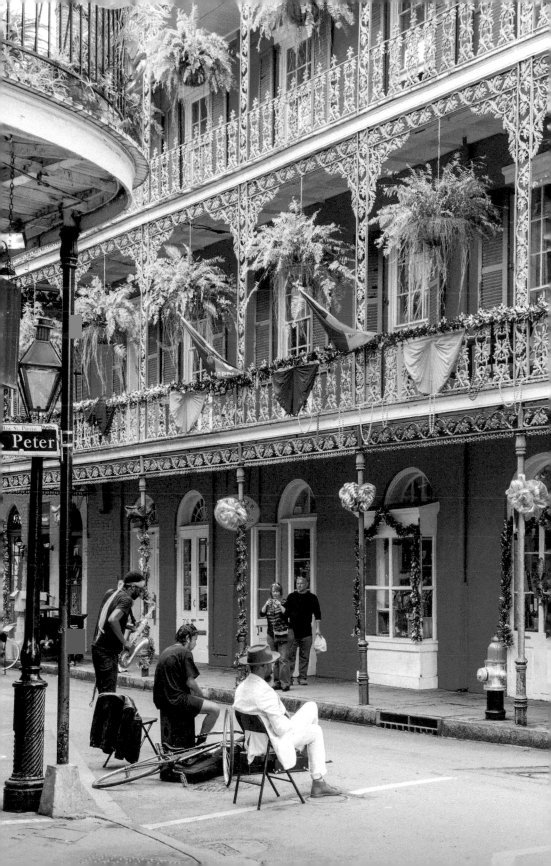

 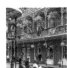
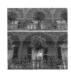

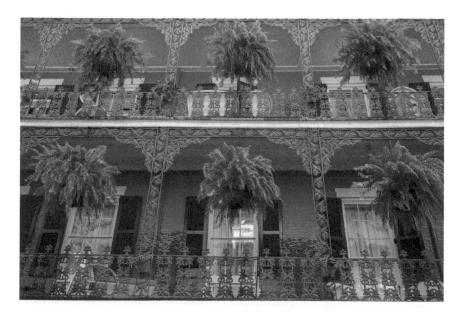

Every photographic travel story needs an establishing shot, and to capture the romance of New Orleans, start at LaBranche House. Hopefully, you'll encounter a street band, where a generous tip can provide you with a lively foreground element and equally lively background music.

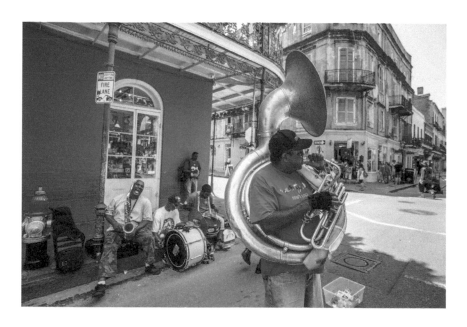

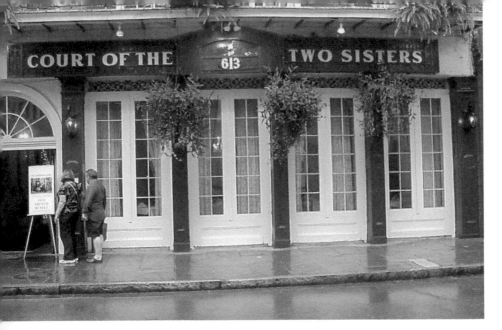

Upper Central Royal Street is an elegant area.

A block southeast of LaBranche House is the Court of the Two Sisters (613 Royal), with a welcoming bar and a colorful courtyard fountain. Enjoy a jazz brunch buffet with Creole classics, then cross the street to discover your future with the Voodoo Bone Lady (628 Royal).

✉ **Addr:**	500-700 Royal St, New Orleans LA 70130	♀ **Where:**	29.95766 -90.065516	
❓ **What:**	Area	◑ **When:**	Anytime	
👁 **Look:**	Northwest	↔ **Far:**	4 m (13 feet)	

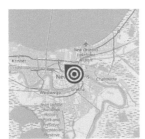
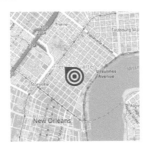
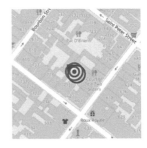

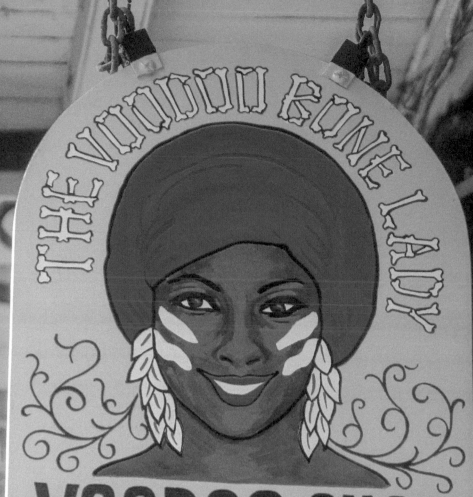

THE VOODOO BONE LADY

VOODOO SHOP

and PSYCHIC READINGS

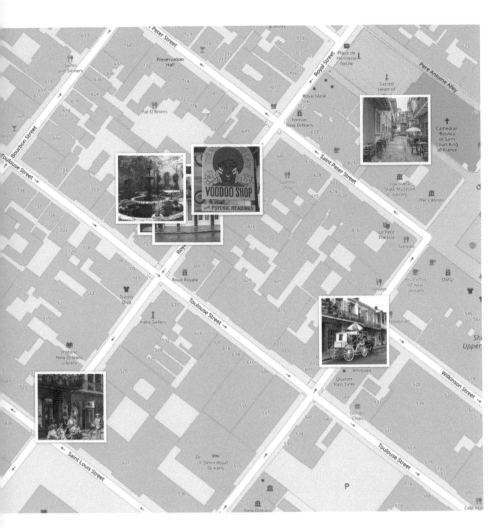

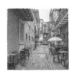

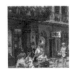

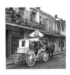

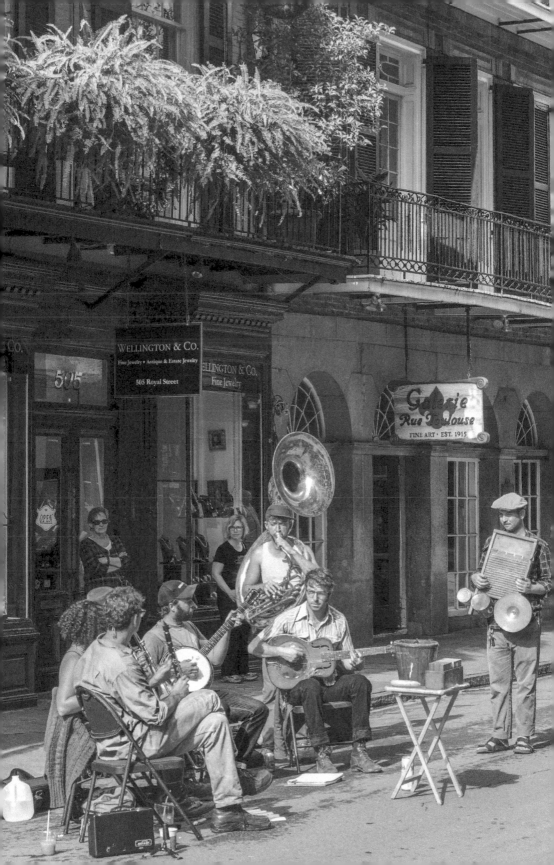

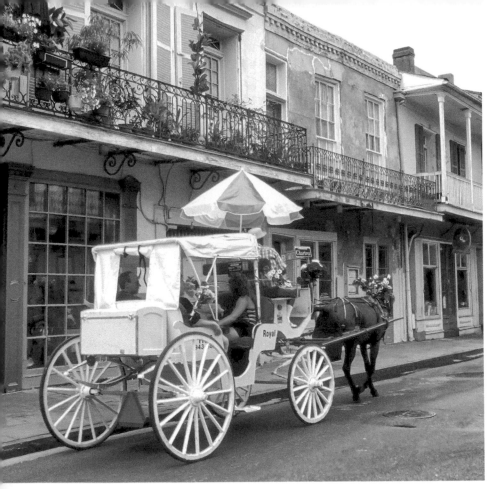

Above: Chartres at Wilkinson; Below: Cabildo Alley from Pirate Alley.

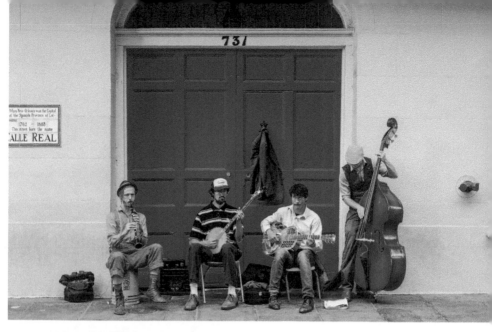

Lower Central Bourbon and Royal lies northeast, confusingly with higher street numbers since "lower" means down river, and Mississippi flows north and east by the French Quarter.

Enjoy live music with colorful backdrops at 731 Royal (above) and 733 Bourbon (below), at Fritzel's European Jazz Pub.

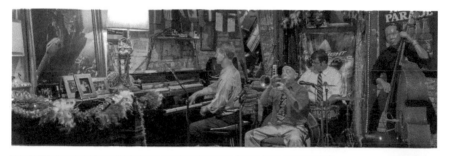

✉ **Addr:**	Bourbon St, New Orleans LA 70116	♀ **Where:**	29.958606 -90.064163
❓ **What:**	Area	◑ **When:**	Anytime
👁 **Look:**	Northwest	↔ **Far:**	12 m (39 feet)

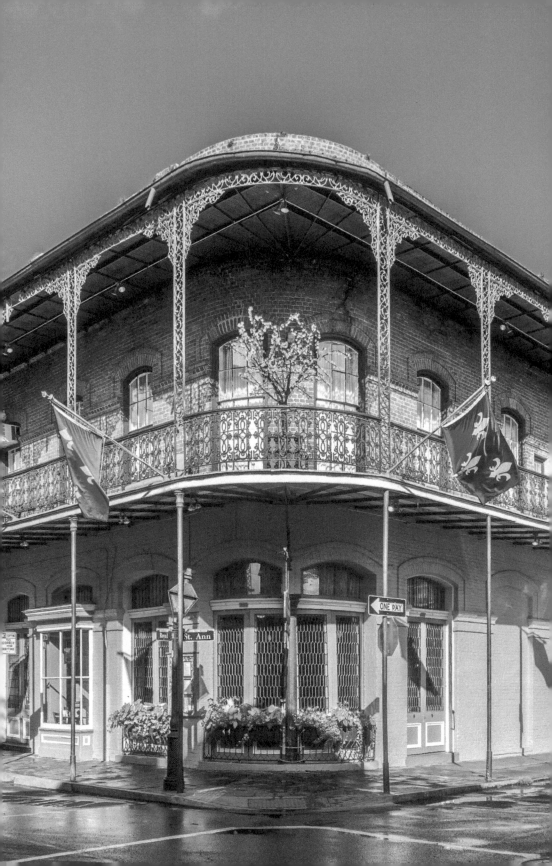

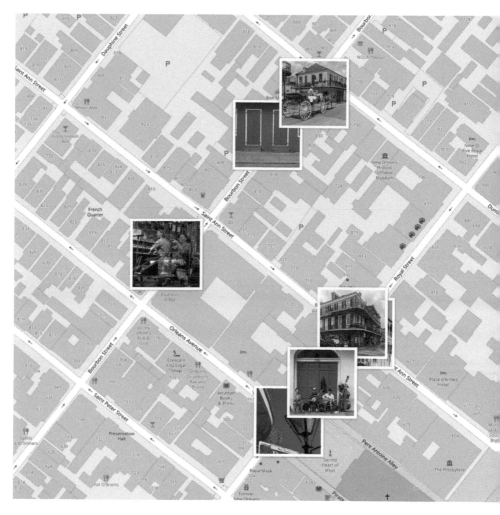

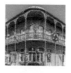

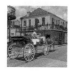

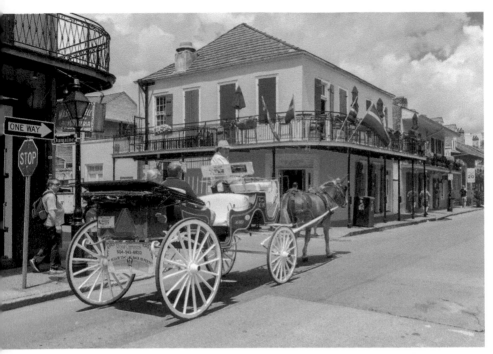

Horse-drawn carriages provide Old World foregrounds for (above) Café Lafitte in Exile at 901 Bourbon Street at Dumaine Street, and (below) 742 Royal Street at St. Ann Street.

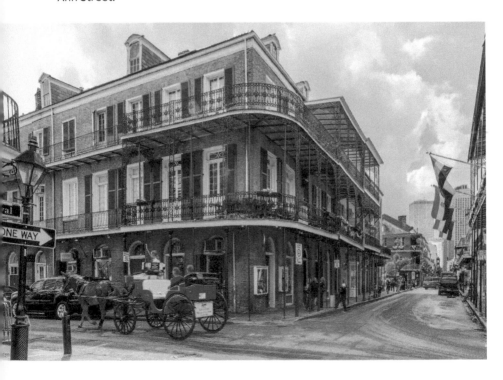

New Orleans Historic Voodoo Museum is one of few
museums in the world dedicated entirely to Voodoo art.

Slaves from French colonies in Africa were
imported by French colonists to help work the
Louisiana land. From 1719 to 1731, the
majority were Fon people (from what is now
Benin) with religions rooted in West African
Dahomeyan Vodun. Generally, these oral
traditions include belief in a supreme creator,
belief in spirits, veneration of the dead, use of
magic and traditional medicine, and
harmonizing nature with the supernatural.

✉ **Addr:**	724 Dumaine St, New Orleans LA 70116	♥ **Where:**	29.959909 -90.063846
❷ **What:**	Museum	◔ **When:**	Anytime
👁 **Look:**	North	W **Wik:**	New_Orleans_Historic_Voodoo_Museum

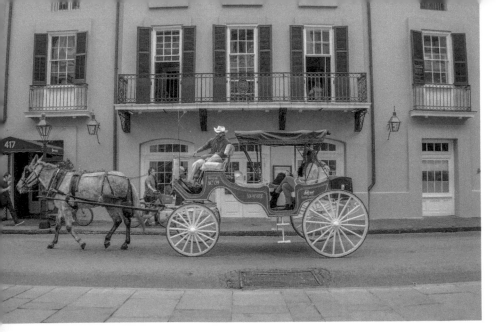

Upper French Quarter is the southwest half of the French Quarter, from Iberville to Orleans, in the upstream direction of the Mississippi River.

Until the early 1800s, most descendants from the French and Spanish colonial period lived in the French Quarter (Vieux Carré), while newer Americans and immigrants settled uptown. Along the division between these two cultures, a canal was planned (but not built) on what is today's Canal Street.

Good photography spots in this area include Brennan's (above), a famous a Creole restaurant at 417 Royal Street, and the House of Blues (right, in the Voodoo Gardens) at 225 Decatur Street.

✉ **Addr:**	417 Royal St, New Orleans LA 70130	♥ **Where:**	29.956001 -90.066473
❓ **What:**	Area	☾ **When:**	Anytime
👁 **Look:**	Northwest	↔ **Far:**	15 m (49 feet)

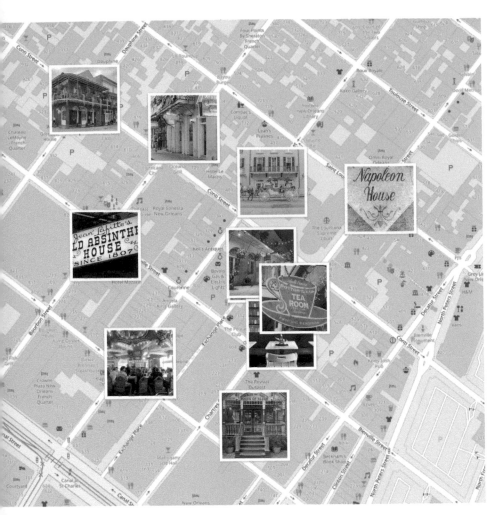

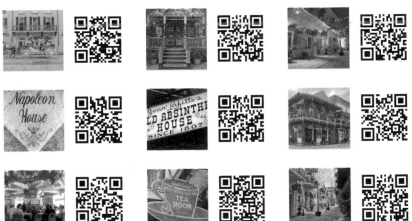

Exchange Place (above); interesting signs (below); and Déjà Vu (bottom).

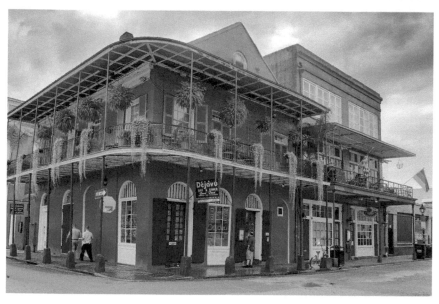

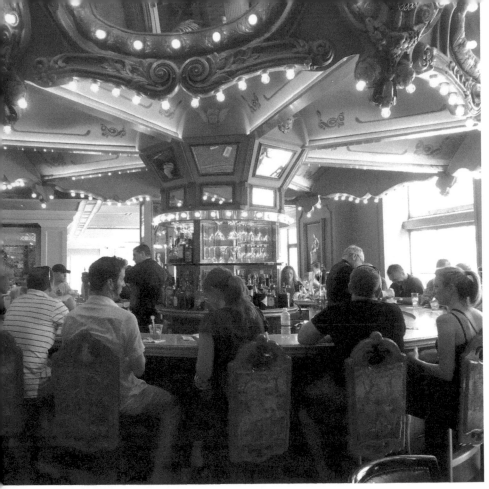

Above: Carousel Bar at Hotel Monteleone is the city's only revolving bar.

World Famous
BOTTOM OF THE CUP
TEA
ROOM
EST. 1929
New Orleans
PSYCHIC READINGS

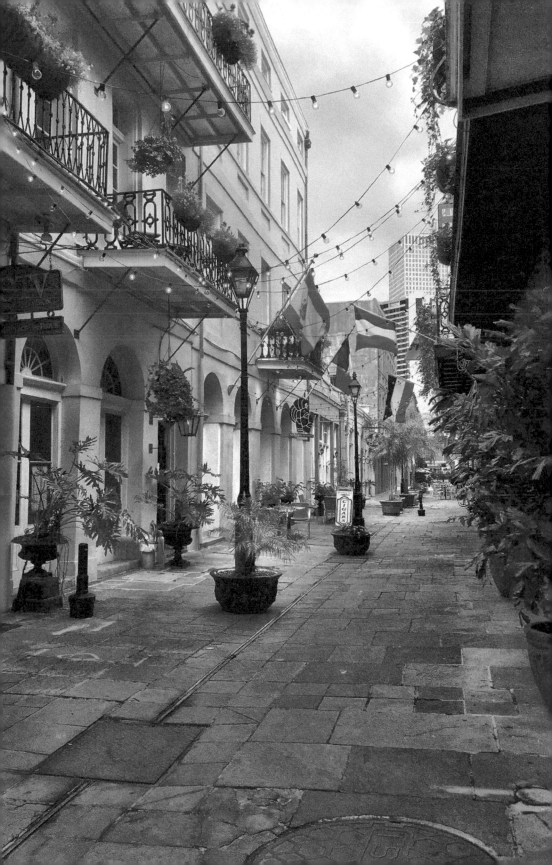

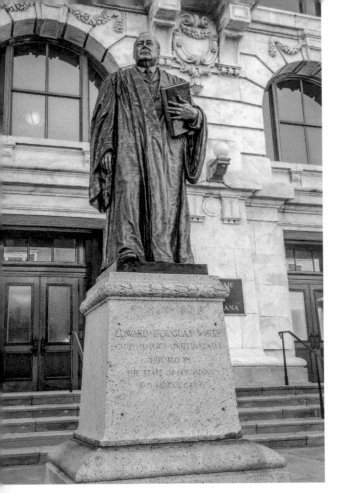

The **Supreme Court of Louisiana** is the highest court in Louisiana, where state law is historically based in the colonial governments of France and Spain during the 18th century.

The circa 1910 state court building occupies a city block at Royal Street (opposite Brennan's), by St. Louis Street. On the main steps stands a statue of Edward Douglas White, a Louisiana native who practiced law in New Orleans, served on the Louisiana Supreme Court, and became the ninth Chief Justice of the United States.

Appropriately, the most photogenic corner of the building (right) is from the south.

✉ **Addr:**	400 Royal St, New Orleans LA 70130	♀ **Where:**	29.956055 -90.066425
❷ **What:**	Building	◑ **When:**	Afternoon
👁 **Look:**	South-southeast	W **Wik:**	Louisiana_Supreme_Court

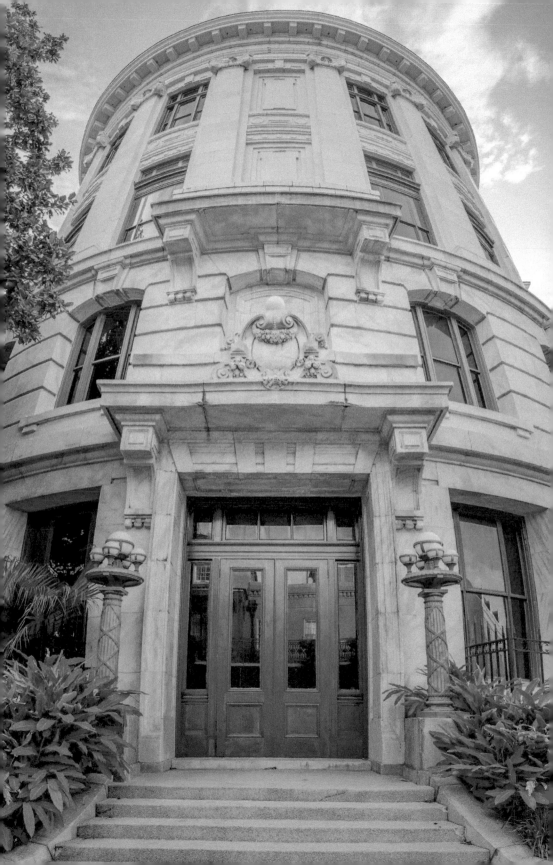

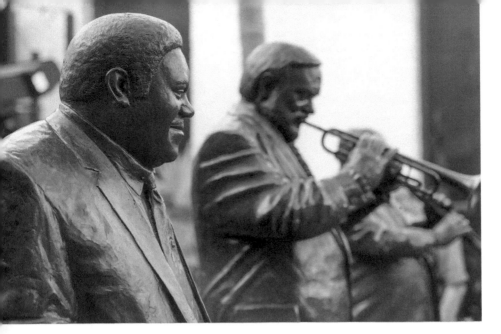

Musical Legends Park is a free, outdoor venue for live jazz performances. Here, you can meet and photograph some of the city's legendary music personalities (or at least statues of them), including Fats Domino, Al Hirt and Pete Fountain (above), plus Louis Prima, Irma Thomas, Ronnie Kole and Chris Owens.

✉ **Addr:**	311 Bourbon St, New Orleans LA 70130	♀ **Where:**	29.955715 -90.068316
❓ **What:**	Park	☾ **When:**	Afternoon
👁 **Look:**	North	↔ **Far:**	3 m (10 feet)

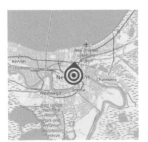
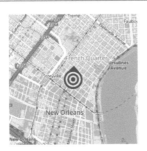
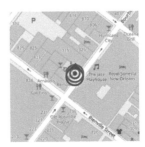

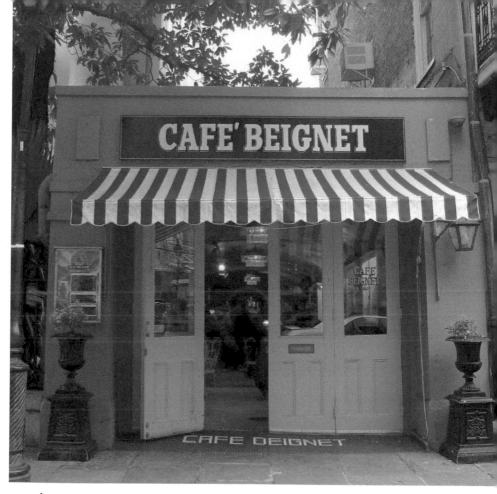

Café Beignet is a charming Cajun coffee shop serving beignets, the official doughnut of Louisiana. The café is to the right of Musical Legends Park and serves the city's famous chicory coffee, popular in Napoleonic-era France and in New Orleans since the American Civil War.

✉ **Addr:**	334 Royal St, New Orleans LA 70130	♀ **Where:**	29.955341 -90.067149
❓ **What:**	Cafe	◑ **When:**	Afternoon
👁 **Look:**	Southeast	↔ **Far:**	13 m (43 feet)

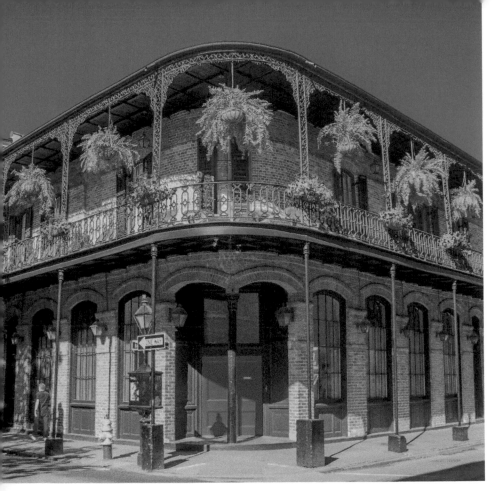

Lower French Quarter is the northeast half, from Orleans to Esplanade. Along Royal Street are more iron-and-fern galleries (at 940 right, 1041 above, and 1217 later). In New Orleans, balconies are supported from the wall and galleries have posts to the ground.

✉ **Addr:**	Bourbon St, New Orleans LA 70116	♥ **Where:**	29.958606 -90.064163
❓ **What:**	Area	◑ **When:**	Anytime
👁 **Look:**	Northwest	↔ **Far:**	12 m (39 feet)

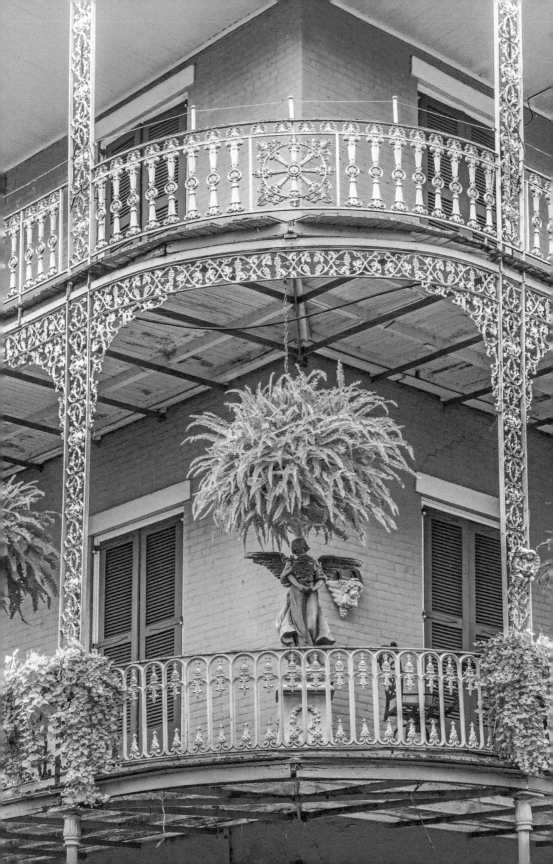

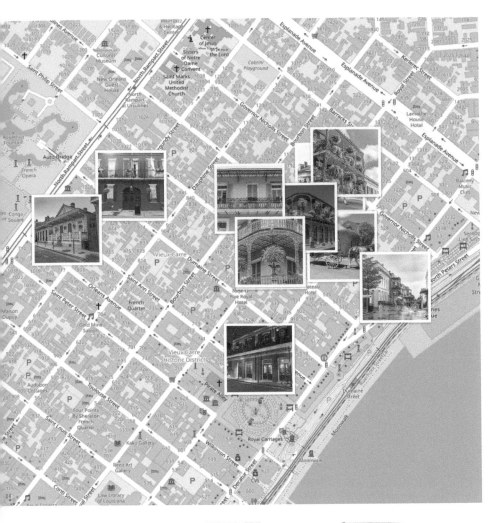

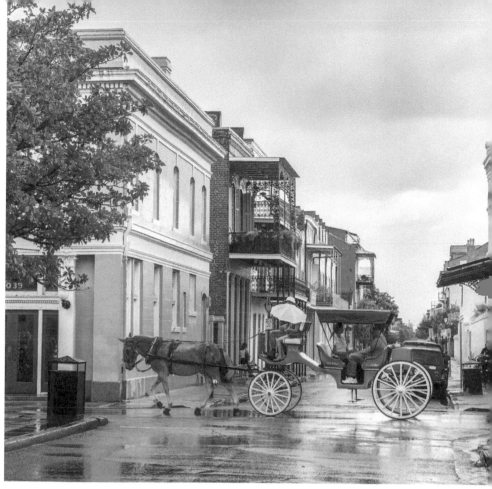

A horse-drawn carriage on Decator Street, photographed from Ursuliness.

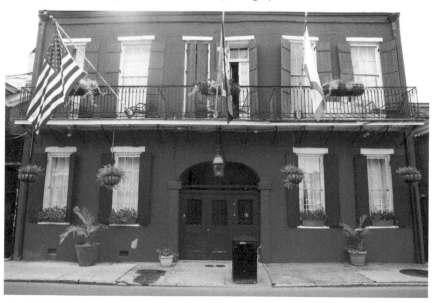

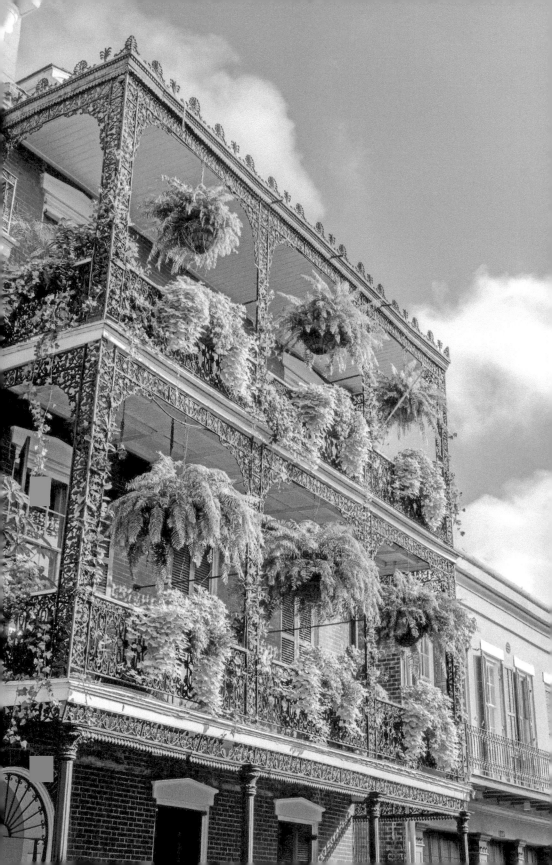

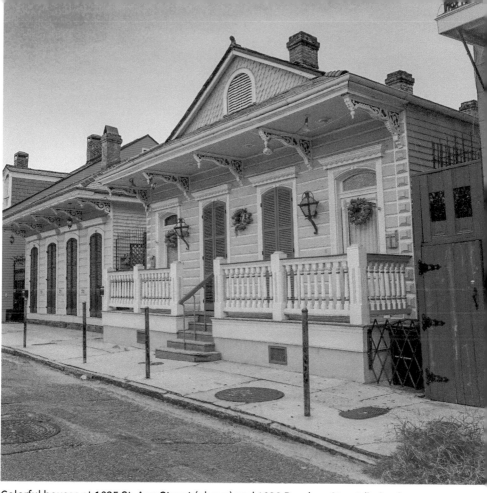

Colorful houses at 1025 St. Ann Street (above) and 1028 Bourbon Street (below).

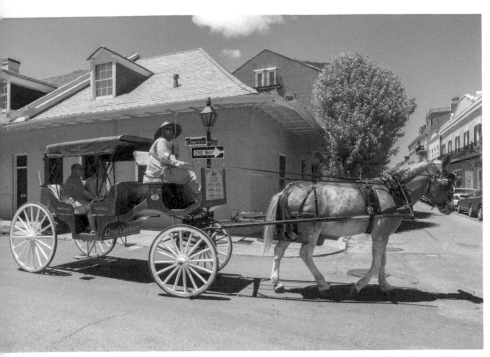

Await your horse-pulled foreground along Chartres Street (above) and Royal Street (below).

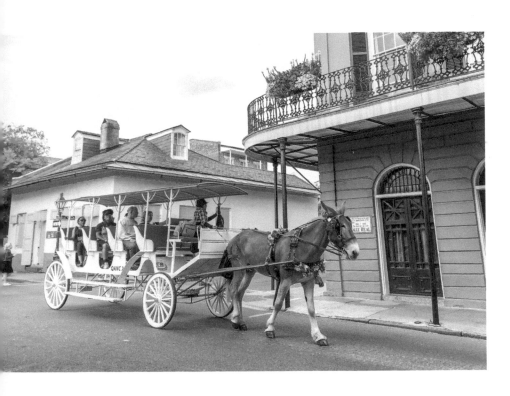

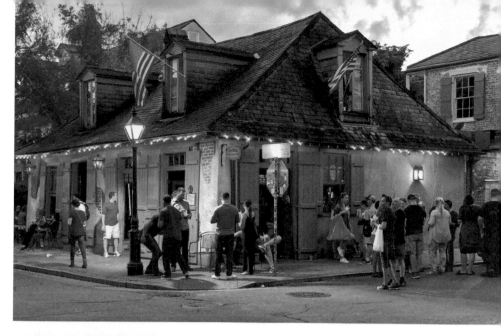

Lafitte's Blacksmith Shop is possibly the oldest building in the United States housing a bar. Built by 1732 in the French Provincial style, the house escaped two great fires due to its slate roofing.

Between 1772 and 1791, French pirate Jean Lafitte and his brother Pierre may have opened a blacksmith forge here as a cover to sell goods seized from ships at sea.

During the War of 1812, in return for legal pardons, Lafitte and his comrades helped General Andrew Jackson defend New Orleans from the British in the final battle.

✉ **Addr:**	925 Bourbon St, New Orleans LA 70116	♀ **Where:**	29.961049 -90.063394
❓ **What:**	Historic building	⟐ **When:**	Anytime
👁 **Look:**	West	W **Wik:**	Lafitte%27s_Blacksmith_Shop

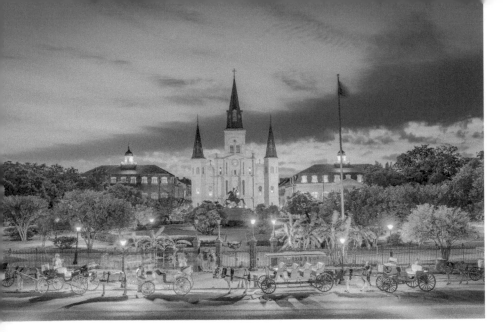

St. Louis Cathedral is the oldest French cathedral in what would become the United States. Founded in 1718, the current structure mainly dates from 1850. The cathedral faces Jackson Square which provides a variety of photo locations.

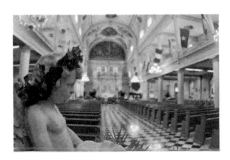 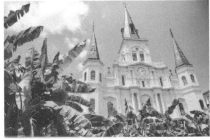

✉ **Addr:**	615 Pere Antoine Alley, New Orleans LA 70116	♀ **Where:**	29.9570679 -90.0621527	
❓ **What:**	Cathedral	◑ **When:**	Morning	
👁 **Look:**	West-northwest	W **Wik:**	St._Louis_Cathedral_(New_Orleans)	

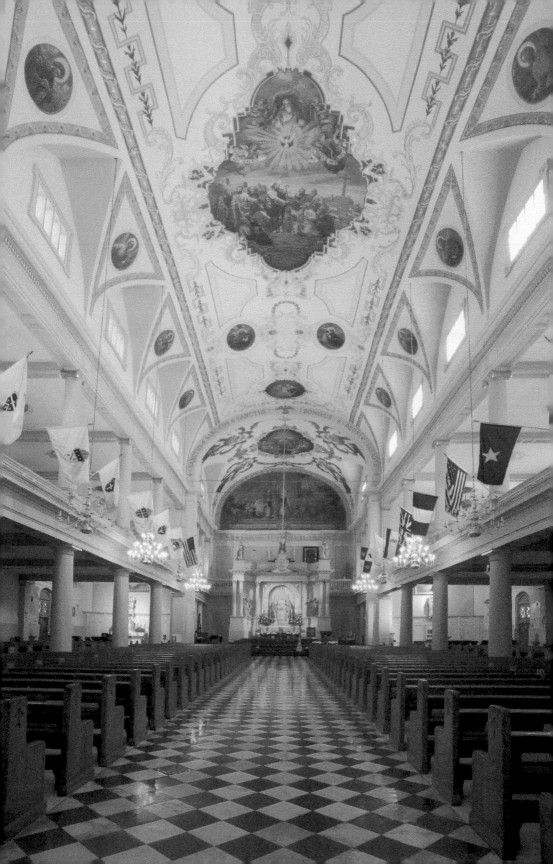

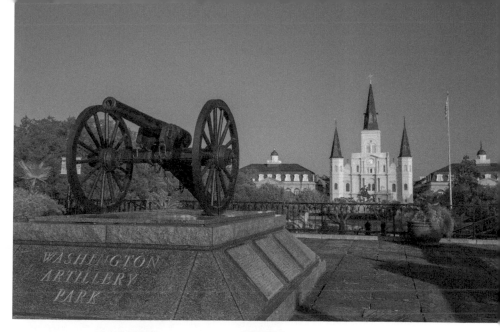

Washington Artillery Park provides a convenient 12-foot-high raised viewpoint....

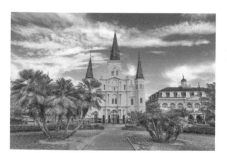

...to photograph horse-drawn carriages with Jackson Park and the cathedral.

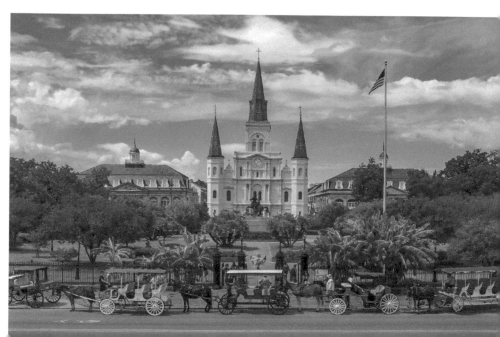

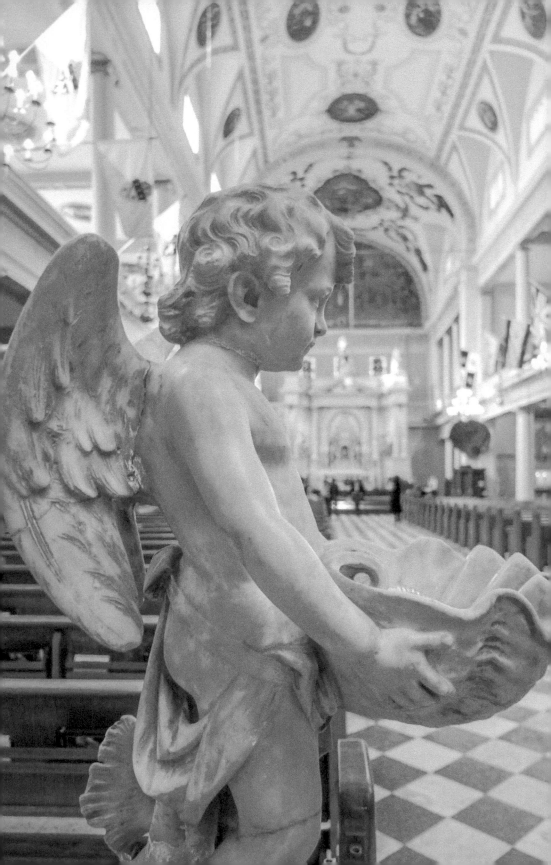

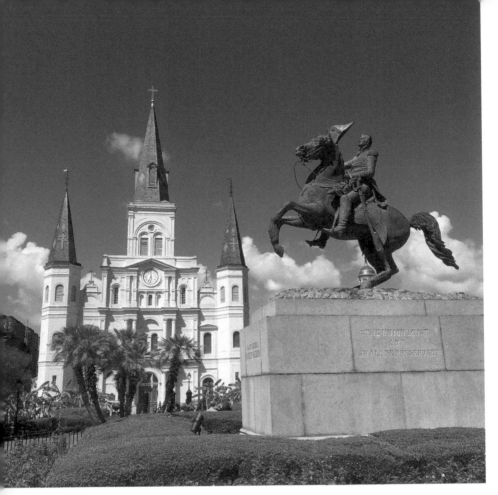

Jackson Square is the historical center of New Orleans. Called Place d'Armes in the French period, the square was renamed after the 1815 Battle of New Orleans for victorious General Andrew Jackson. In the center, is an 1856 statue of Jackson by Clark Mills.

✉ **Addr:**	Jackson Square, New Orleans LA 70116	♥ **Where:**	29.957356 -90.062887
❓ **What:**	Public square	☽ **When:**	Anytime
👁 **Look:**	North-northwest	W **Wik:**	Jackson_Square_(New_Orleans)

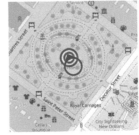

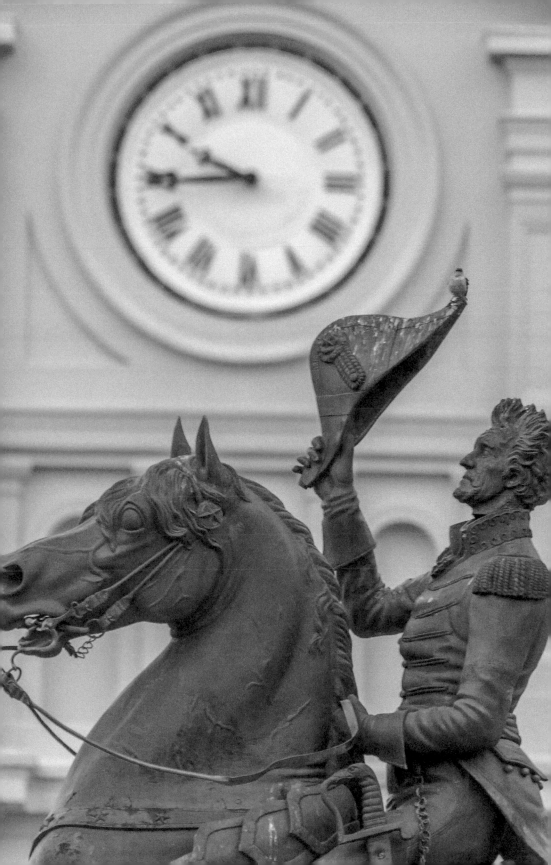

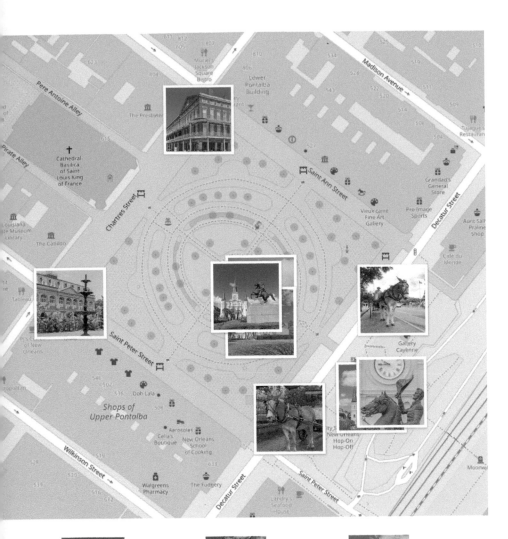

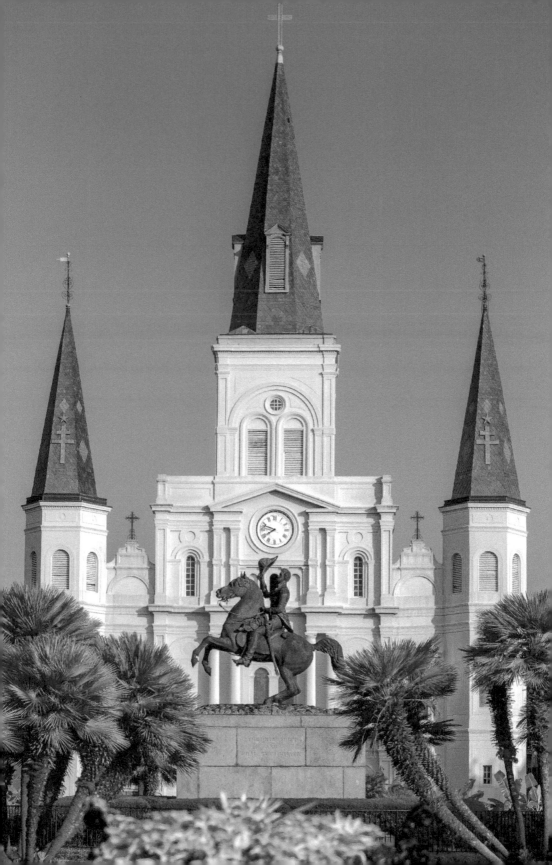

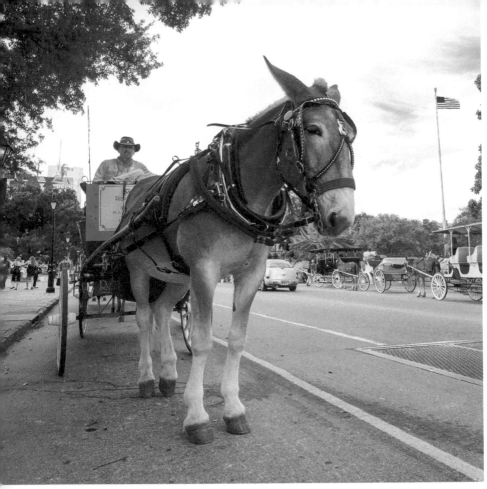

Below: One of the 1840s Pontalba Buildings. Right: The 1799 Spanish Cabildo.

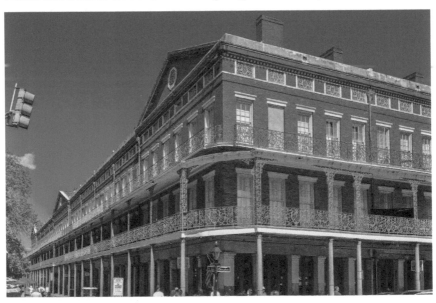

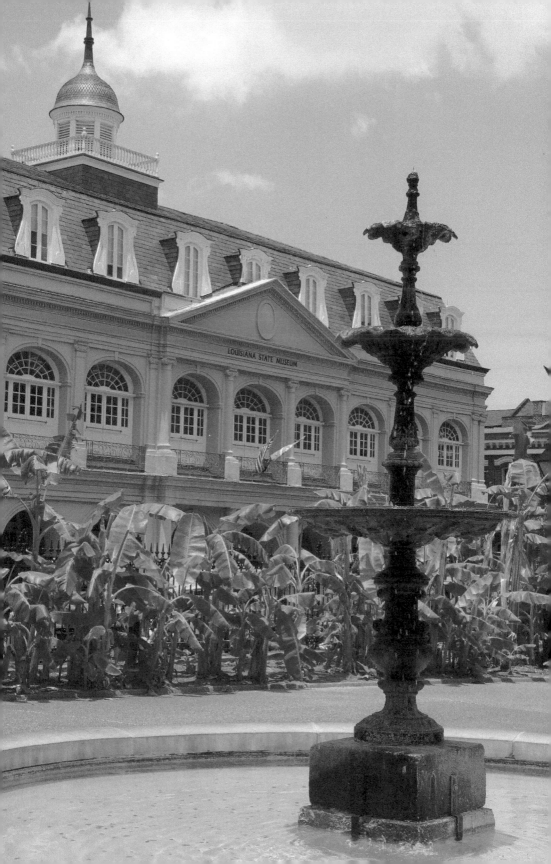

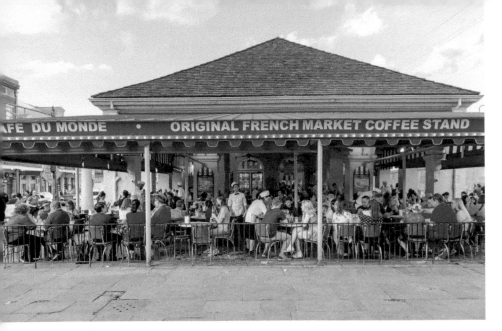

Café du Monde ("World Cafe") is a landmark coffee shop serving two New Orleans icons: beignets and coffee, both introduced to North America by French colonists through New Orleans during the 1700s. Beignets are square doughnuts with powdered sugar, served in sets of three. Established in 1862, Café du Monde is open 24/7, closing only for Christmas Day and nearby hurricanes.

✉ **Addr:**	800 Decatur St, New Orleans LA 70116	♀ **Where:**	29.957363 -90.061943
❓ **What:**	Coffee shop	◐ **When:**	Afternoon
👁 **Look:**	Northeast	Ⓦ **Wik:**	Café_du_Monde

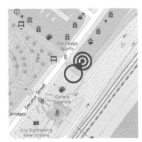

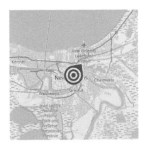
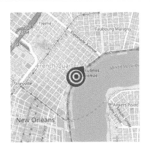

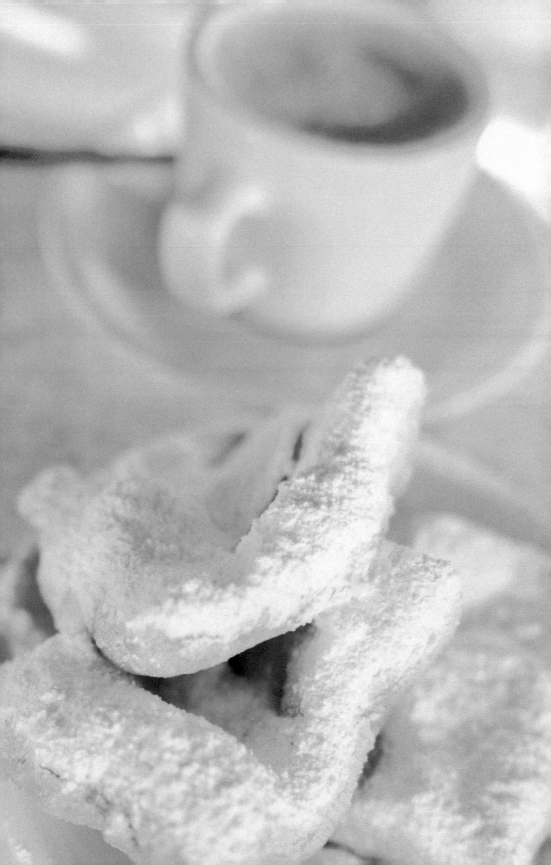

 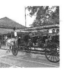 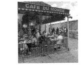

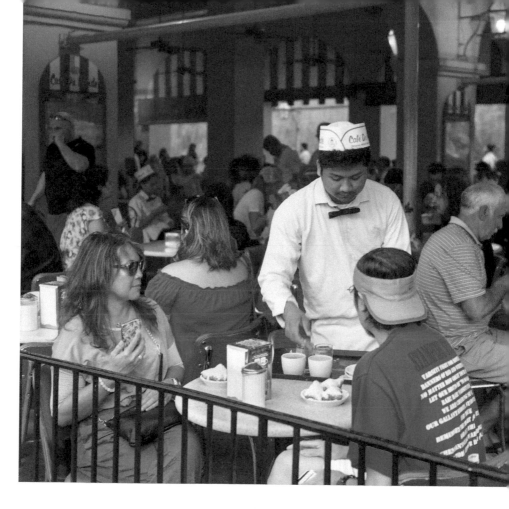

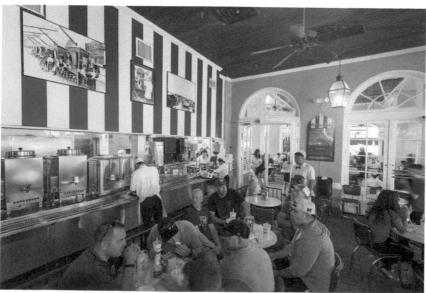

French Quarter > Jackson Square > Café du Monde

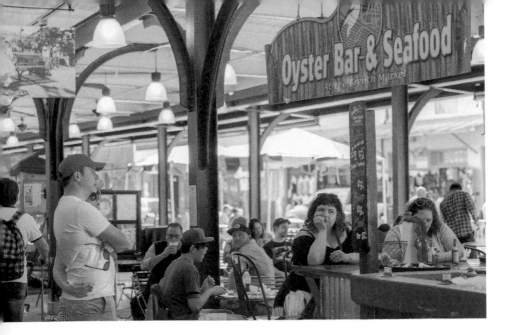

The **French Market** is a market spanning six blocks of the French Quarter along the riverfront. Founded as a Native American trading post predating European colonization, the market is the oldest of its kind in the United States.

Here, you can photograph New Orleans favorites, including crawfish, Cajun food, and Creole cooking. Get low and close for detail shots, such as these tempting iced oysters, and go wide for scenic shots (above and below-right) to capture the "flavor" of the market.

Turn the flash off to get an image using just the natural light. To add a bit of brightness to your shot, consider adding some exposure compensation, such as +1 EV, which is one exposure stop (twice the aperture size or half the shutter speed). Stand your camera on a firm surface to reduce camera shake.

✉ **Addr:**	1008 N Peters St, New Orleans LA 70116	📍 **Where:**	29.958941 -90.060285
❓ **What:**	Market	🌙 **When:**	Anytime
👁 **Look:**	Northeast	W **Wik:**	French_Market

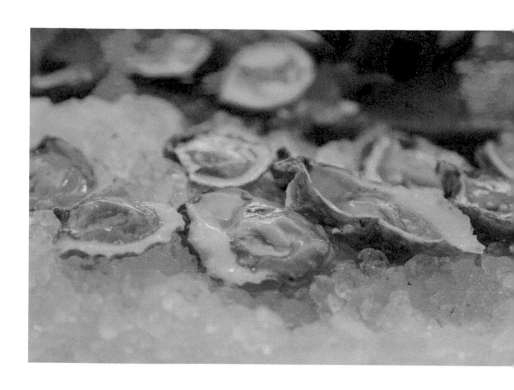

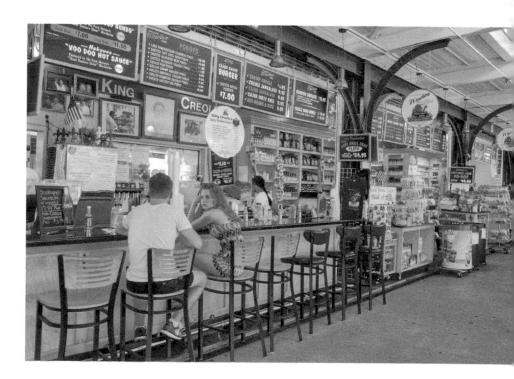

French Quarter > Riverfront > French Market

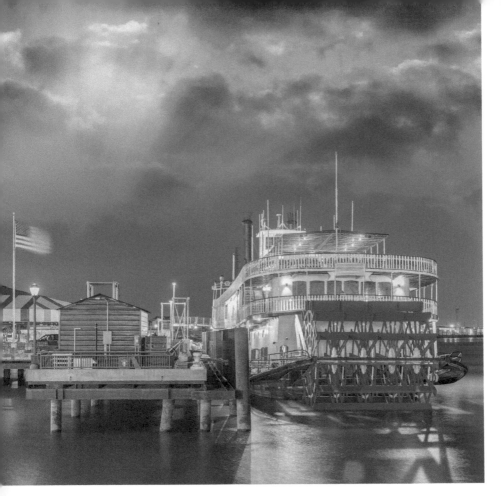

Steamer Natchez is the last authentic steamboat on the Mississippi River. The steam engines were built in 1925 for another ship, and power a 25 foot (7.6 m) sternwheel made. Launched in 1975, the ship is best photographed from Riverwalk Gazebo in Woldenberg Park.

✉ **Addr:**	451 St Peter, New Orleans LA 70130	♀ **Where:**	29.954387 -90.062612	
❓ **What:**	Steamboat	◑ **When:**	Anytime	
👁 **Look:**	North-northeast	W **Wik:**	Natchez_(boat)	

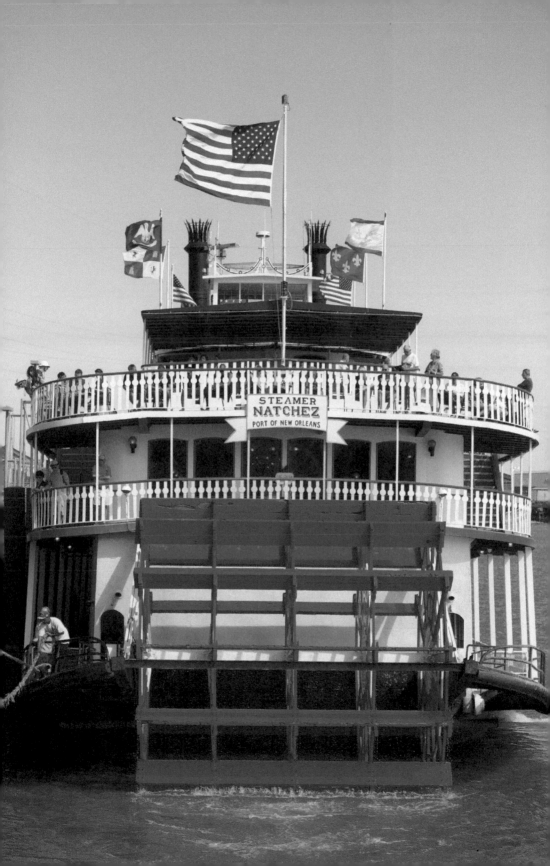

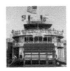
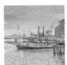

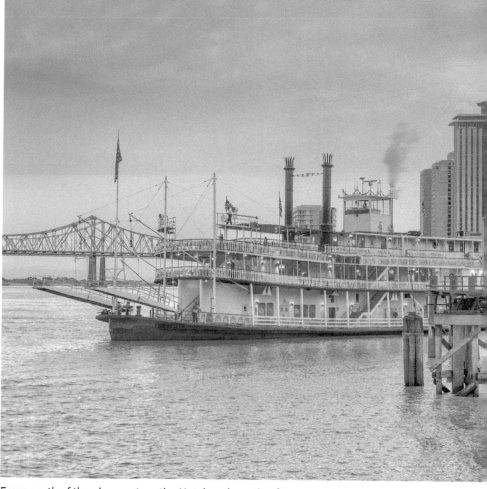

From north of the pier, capture the Natchez departing for an evening cruise.

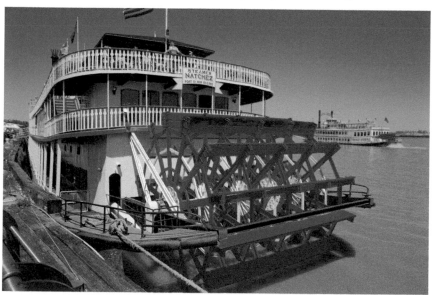

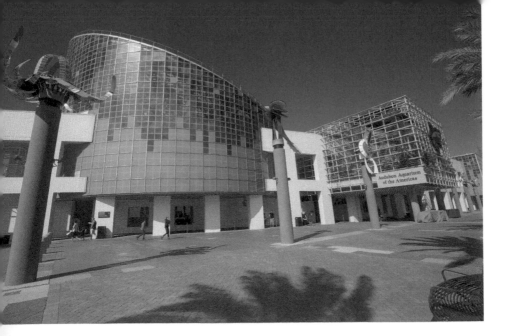

The **Audubon Aquarium of the Americas** is a sea-life museum in Woldenberg Park, on the edge of the French Quarter. Opened in 1990, the aquarium displays over 10,000 animals from over 500 species.

From the plaza by the Mississippi and Canal Street, you can photograph the cylindrical atrium. To get a deep blue sky like this, use a polarizer filter which reduces glare and is great for water.

The Caribbean reef exhibit features a clear, 30-foot (9 m) long tunnel, which makes a terrific place to take photos. The popular Penguins Exhibit has an adorable and photogenic colony of over 20 African penguins.

✉ **Addr:**	1 Canal St, New Orleans LA 70130	♥ **Where:**	29.950089 -90.062672
❷ **What:**	Aquarium	◐ **When:**	Morning
👁 **Look:**	West-northwest	W **Wik:**	Aquarium_of_the_Americas

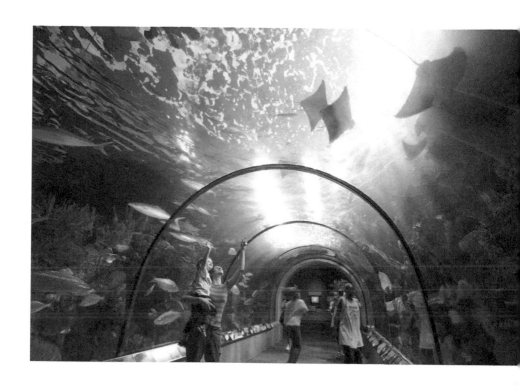

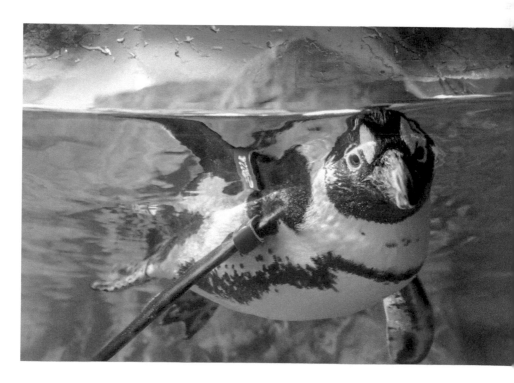

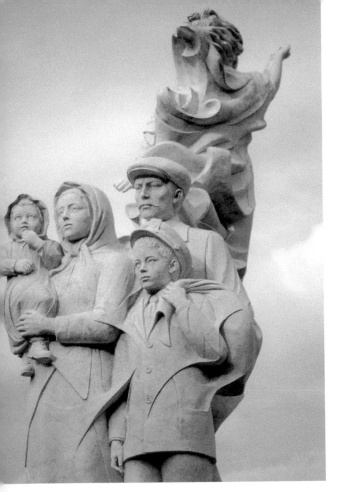

Monument to the Immigrant is a

marble sculpture in Woldenberg Park, by the Mississippi River. Erected in 1995, the monument is a reminder that New Orleans was founded by immigrants.

Surprisingly, for a city colonized by French and ruled by Spanish, the largest European heritage today is Italian. After the Civil War, when freed men could move north for industrial jobs, Louisiana planters found new labor in Sicily. By 1881, three steamships per month ran between New Orleans and Sicily.

✉ **Addr:**	Woldenberg Park, New Orleans LA 70130	◉ **Where:**	29.953629 -90.062825
❓ **What:**	Memorial	◷ **When:**	Afternoon
👁 **Look:**	East	↔ **Far:**	9 m (30 feet)

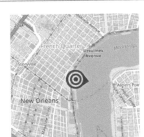

Joan of Arc is a gilded bronze equestrian statue of the Maid of Orleans. Located at the Place de France by the French Market, this was a gift by French President Charles de Gaulle in 1964.

The teenage Joan of Arc saved Orléans in 1429, using her banner and artillery.

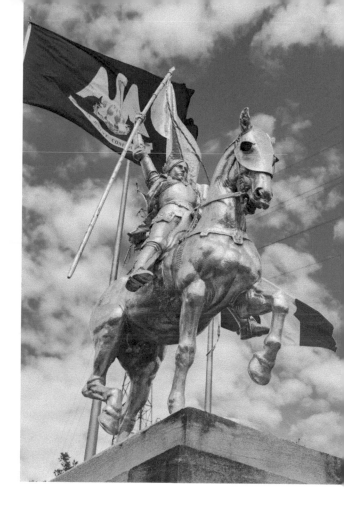

✉ **Addr:**	Place de France, New Orleans LA 70116	♀ **Where:**	29.958913 -90.060744
❷ **What:**	Equestrian statue	◑ **When:**	Afternoon
👁 **Look:**	East	↔ **Far:**	5 m (16 feet)

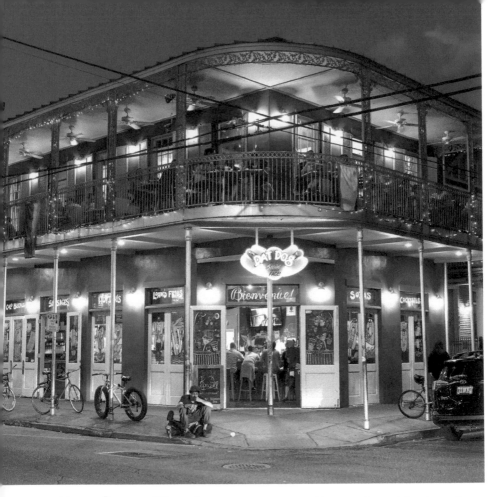

Frenchmen Street is seemingly a small extension of the French Quarter, in neighboring Marigny (Faubourg Marigny). Photogenic businesses near the intersection with Chartres Street include Dat Dog (above), Praline Connection, Snug Harbor and Favela Chic.

✉ **Addr:**	Frenchmen St, New Orleans LA 70116	♀ **Where:**	29.963463 -90.057788
❷ **What:**	Street	☽ **When:**	Anytime
👁 **Look:**	Northeast	W **Wik:**	Frenchmen_Street

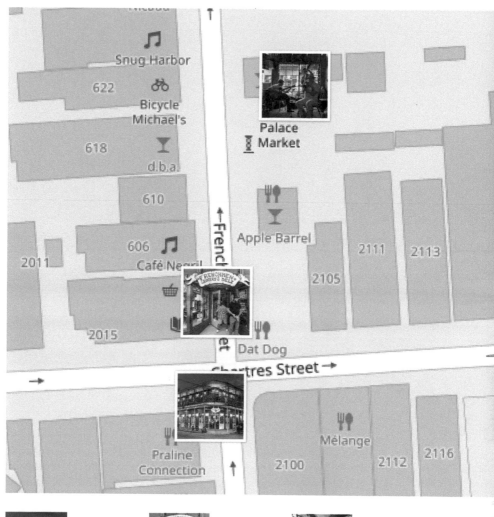

Snug Harbor 🎵

622

Bicycle Michael's 🚲

618 🍸
d.b.a.

610

2011

606 🎵
Café Negril

Apple Barrel 🍴 🍸

2015

French

Dat Dog 🍴

2105

2111

2113

Palace Market ⏳

Chartres Street →

Praline Connection 🍴

2100

Mélange 🍴

2112

2116

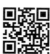
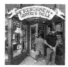

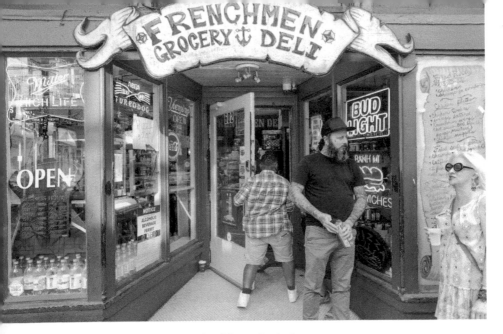

The Frenchman Grocery and Deli has a lively frontage.

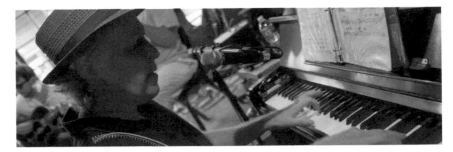

Above and below: The Spotted Cat Music Club has a stage in a bay window.

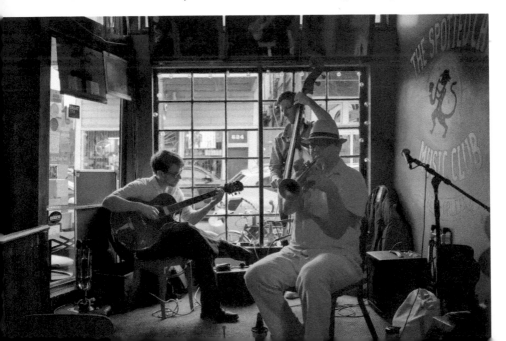

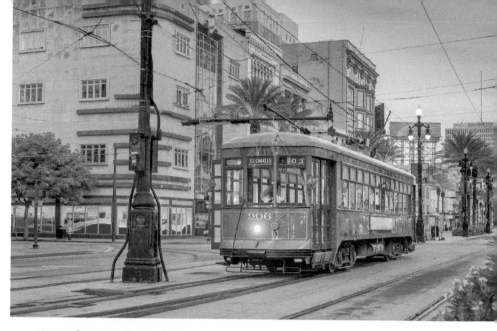

The **Canal Streetcar line** is a historic streetcar line, first operated in 1861 as a horse-drawn streetcar service.

A good photography spot is from the palm-tree lined median between Royal Street and Bourbon Street (above and below-right).

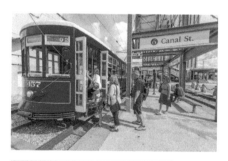

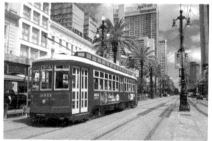

✉ **Addr:**		♀ **Where:**	29.9535806 -90.069523	
❓ **What:**	Historic streetcar line	◑ **When:**	Anytime	
👁 **Look:**	West	Ｗ **Wik:**	Canal_Streetcar_Line	

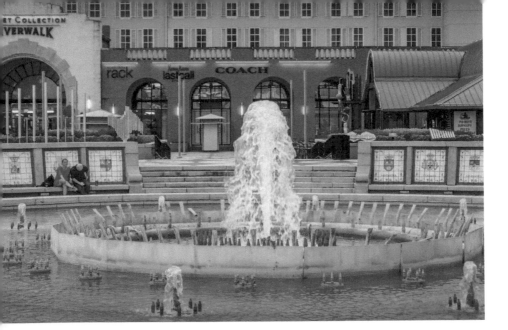

Riverwalk is a shopping area with a fountain at Spanish Plaza (above) dedicated in 1976 and the Creole Queen paddlewheeler (right) built in 1983.

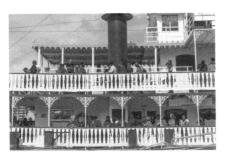

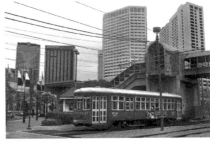

✉ **Addr:**	2 Canal St, New Orleans LA 70130	♀ **Where:**	29.949108 -90.062871	
❓ **What:**	Area	☾ **When:**	Anytime	
👁 **Look:**	South-southeast	↔ **Far:**	15 m (49 feet)	

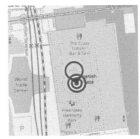

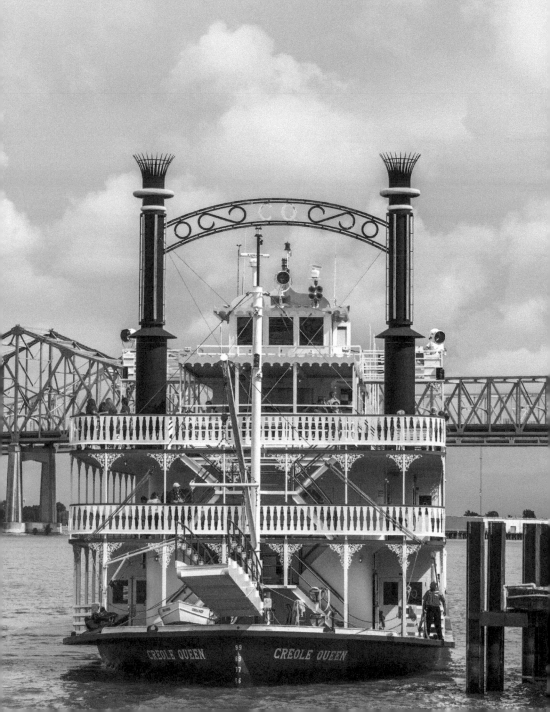

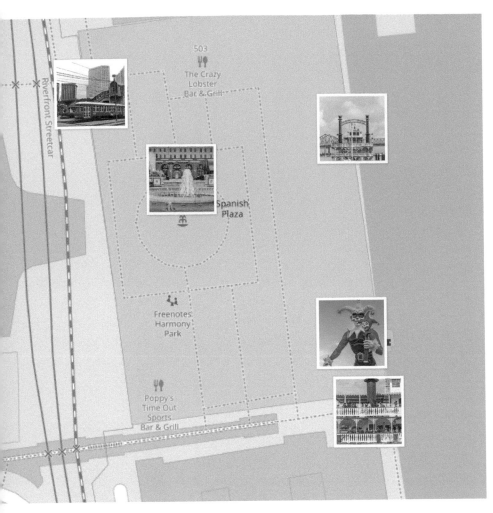

503

The Crazy
Lobster
Bar & Grill

Spanish
Plaza

Freenotes
Harmony
Park

Poppy's
Time Out
Sports
Bar & Grill

Riverfront Streetcar

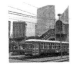
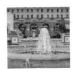

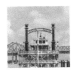

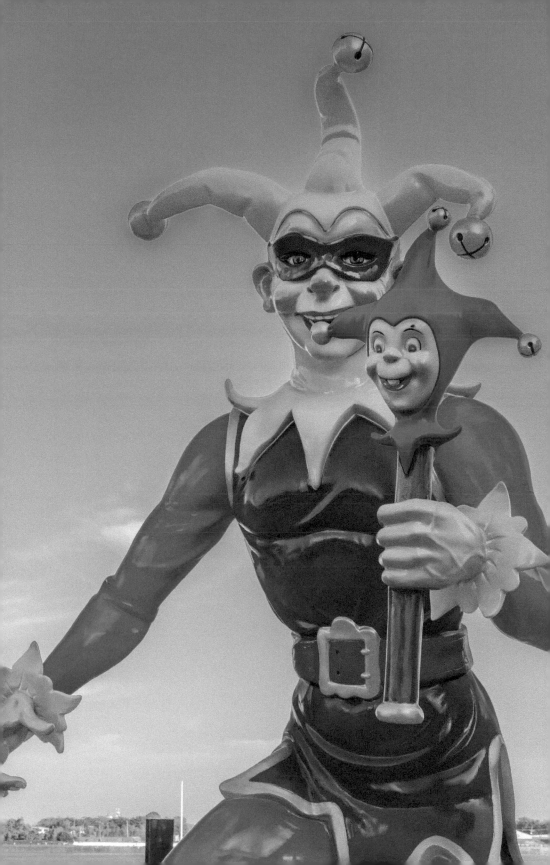

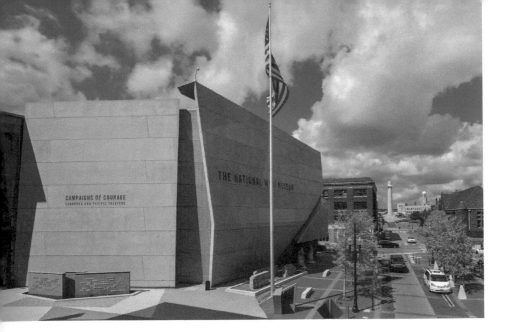

The **National WWII Museum** focuses on the contribution made by the United States to Allied victory in World War II.

The amphibious landing craft crucial to D-Day were designed and built in New Orleans, originally to transport lumber in the shallow swamps. Designed by Andrew Higgins, the "Higgins Boats" allowed armies to unload at open beaches instead of heavily guarded ports, and Higgins Industries quickly became one of the world's largest manufacturers.

The photograph above is taken from a pedestrian bridge. Inside, exhibits include a Douglas C-47 Skytrain (above right) and a Sherman tank.

✉ **Addr:**	945 Magazine St, New Orleans LA 70130	♀ **Where:**	29.942852 -90.070448
❓ **What:**	Museum	◐ **When:**	Morning
👁 **Look:**	West	W **Wik:**	The_National_WWII_Museum

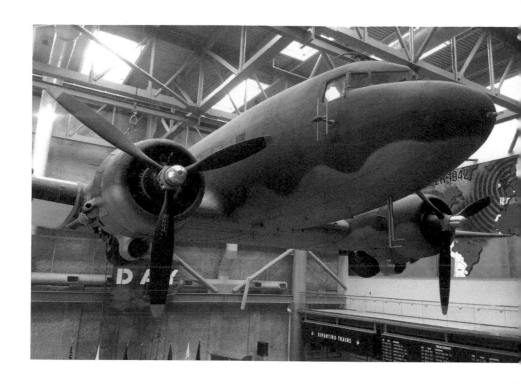

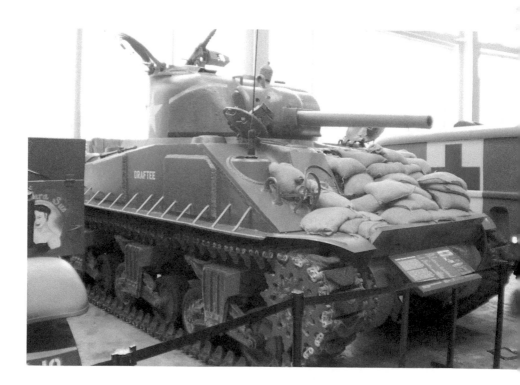

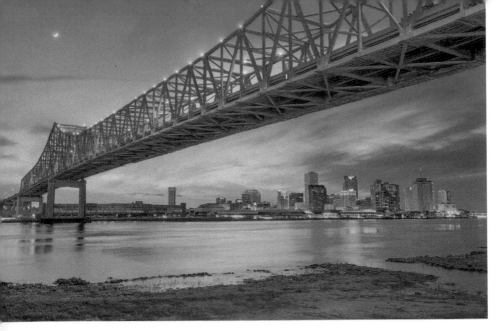

Crescent City Connection are twin cantilever bridges. The Mississippi River Trail on the east side in Gretna has the best view (above and below-right). The top of a parking lot off Annunciation Street is one of the few high-vantage spots on the west/city side (below-left).

✉ **Addr:**	Crescent City Connection, New Orleans LA 70130	📍 **Where:**	29.936472 -90.053955
❓ **What:**	Bridge	🕐 **When:**	Anytime
👁 **Look:**	West-northwest	W **Wik:**	Crescent_City_Connection

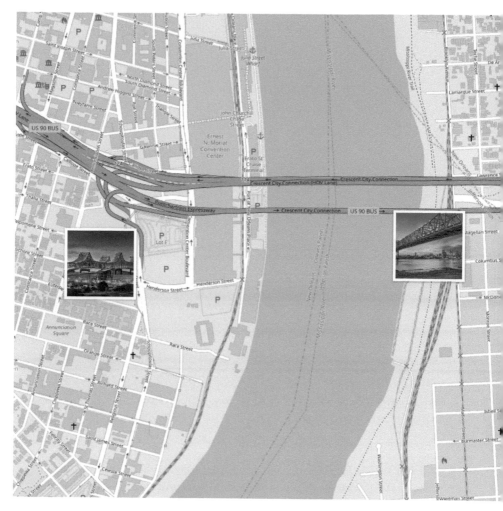

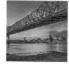 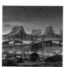 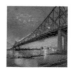

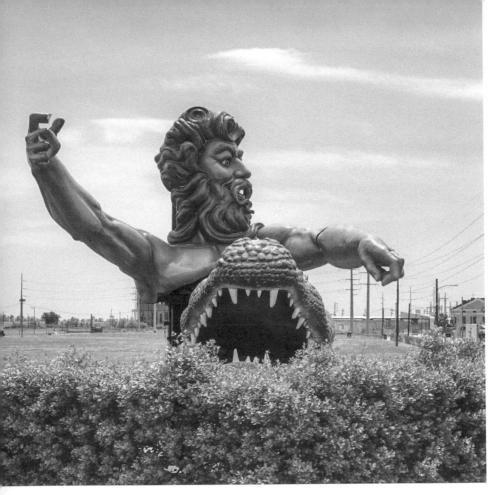

Mardi Gras World is a working warehouse where the famous parade floats are made and stored. You can photograph a hedge-topping alligator and giant jester head by the entrance, and take a paid tour for more sights.

✉ **Addr:**	1380 Port of New Orleans Pl, New Orleans LA 70130	♀ **Where:**	29.935275 -90.061774
❓ **What:**	Building	☾ **When:**	Afternoon
👁 **Look:**	South-southeast	Ⓦ **Wik:**	Mardi_Gras_World

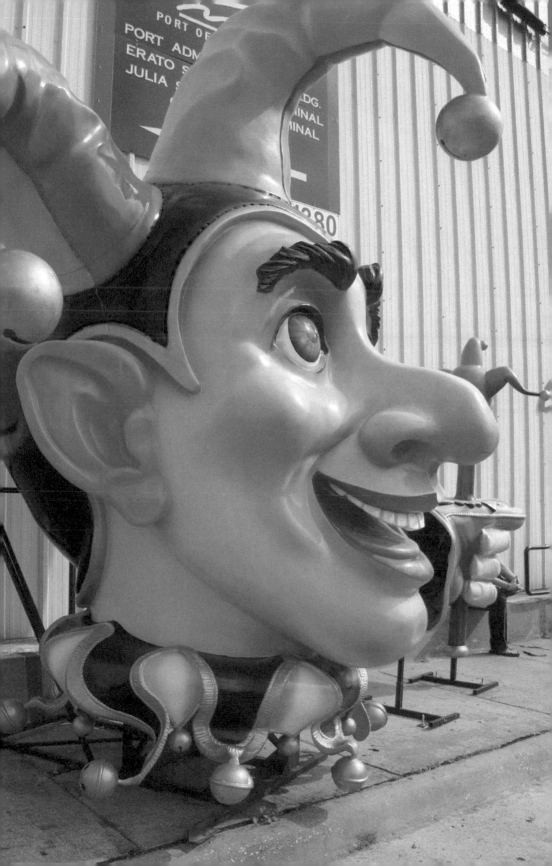

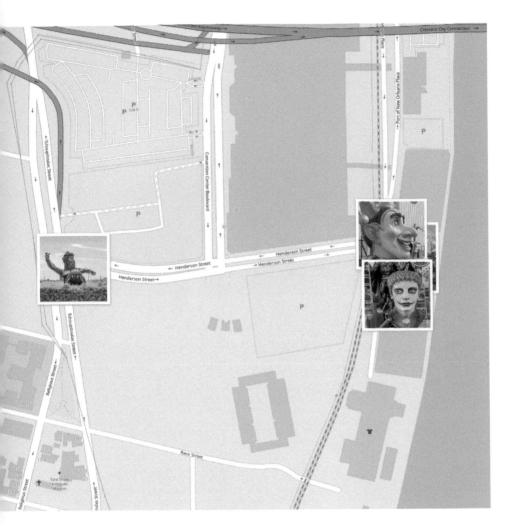

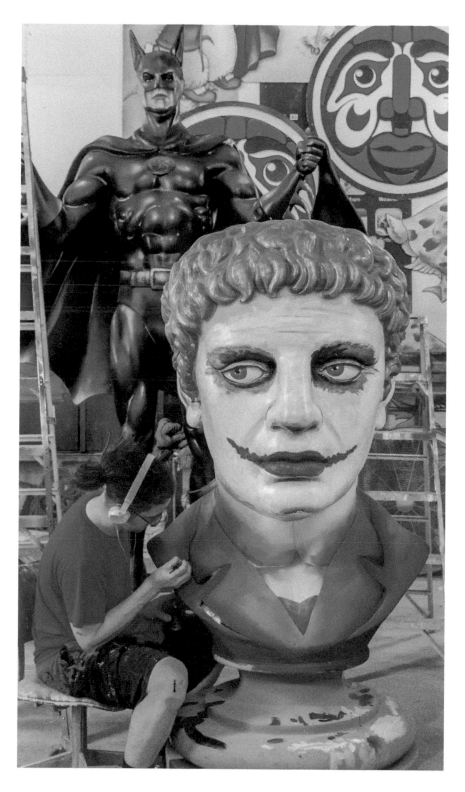

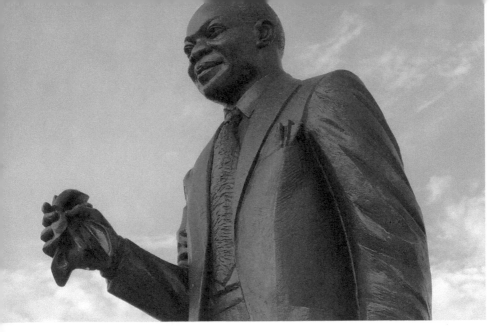

Louis Armstrong Park is a 32-acre park located in the Tremé neighborhood, across from the French Quarter. Visitors are greeted by the New Orleans-born jazz legend himself, as a 12-foot (3.6 m) tall statue by Elizabeth Catlett. Another NOLA native represented is ragtime cornet player Buddy Bolden (right), credited with developing jazz by mixing ragtime, blues, gospel, and improvisation.

The park grew from a meeting place for slaves, who were allowed Sundays off work and could gather outside the city. A law in 1817 made Place des Nègres (now Congo Square) the only legal gathering spot. As African music had been suppressed in the Protestant colonies and states, the weekly gatherings at Congo Square became a famous destination for visitors.

✉ **Addr:**	1130 Dumaine St, New Orleans LA 70116	♀ **Where:**	29.962389 -90.068555
❓ **What:**	Park	☾ **When:**	Afternoon
👁 **Look:**	North	Ⓦ **Wik:**	Louis_Armstrong_Park_(New_Orleans)

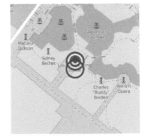

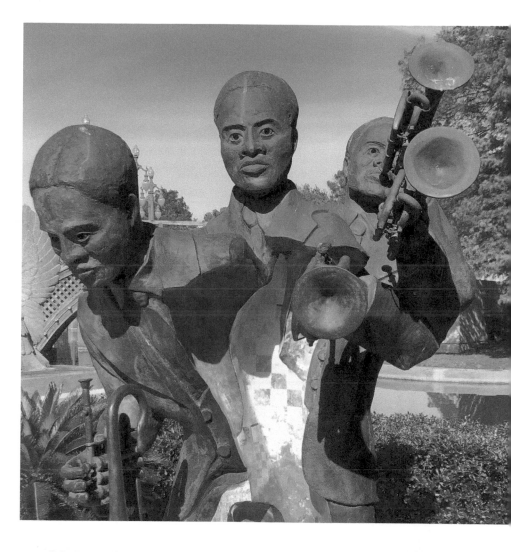

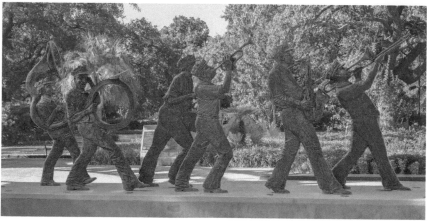

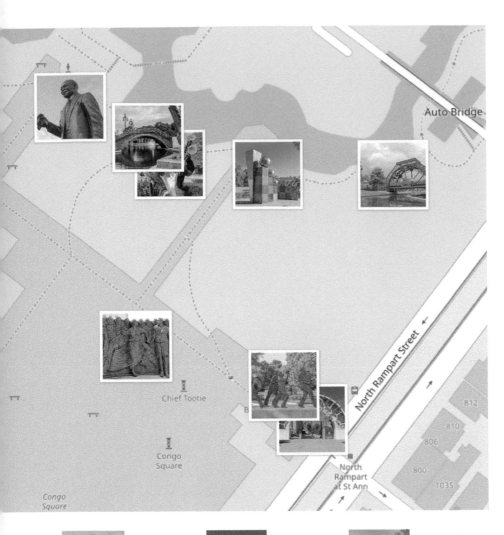

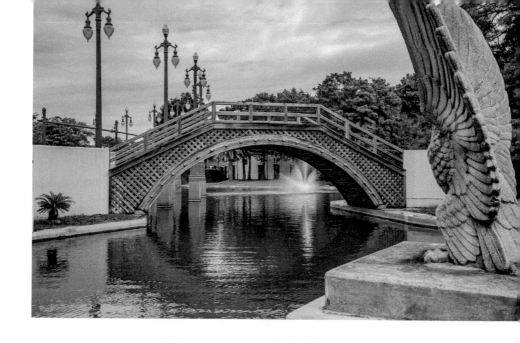

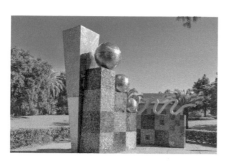
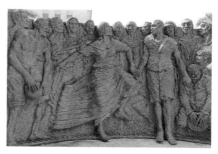

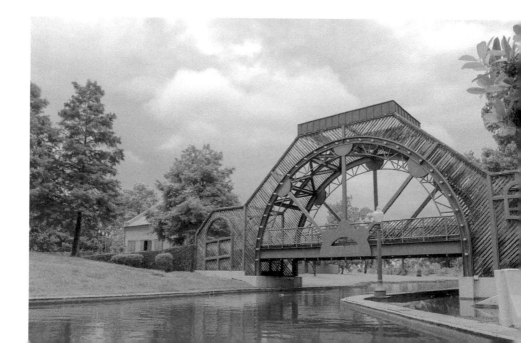

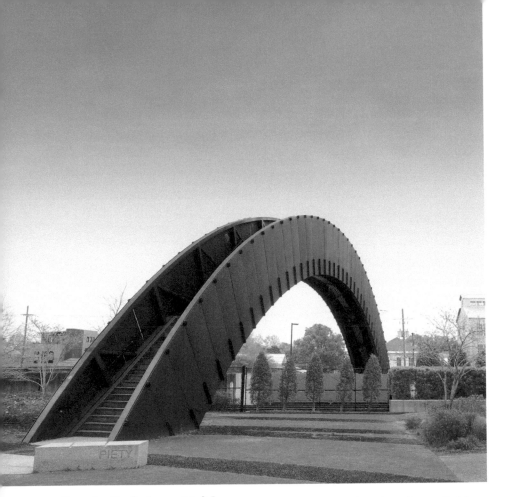

Rusty Rainbow Bridge is an apt nickname for Piety Street Bridge, where pedestrians cross railroad tracks in Crescent Park in the Bywater neighborhood.

✉ **Addr:**	3230 Chartres St, New Orleans LA 70117	📍 **Where:**	29.961092 -90.043354
❓ **What:**	Pedestrian bridge	🌙 **When:**	Afternoon
👁 **Look:**	North	↔ **Far:**	40 m (120 feet)

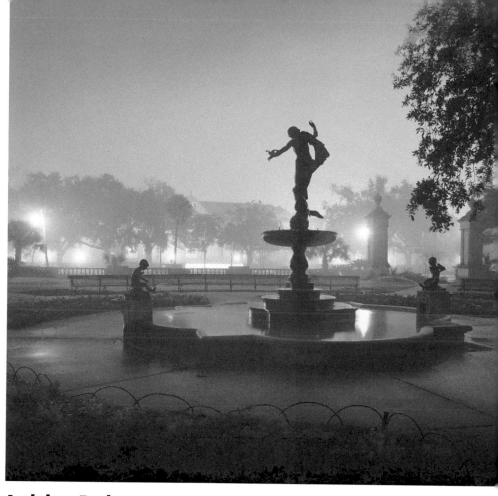

Audubon Park is a city park located in the Uptown neighborhood of New Orleans. Gumbel Fountain (above) anchors the north entrance.

✉ **Addr:**	6500 St Charles Ave, New Orleans LA 70118	♀ **Where:**	29.934219 -90.123776
❷ **What:**	Park	◑ **When:**	Afternoon
◉ **Look:**	Northeast	W **Wik:**	Audubon_Park_(New_Orleans)

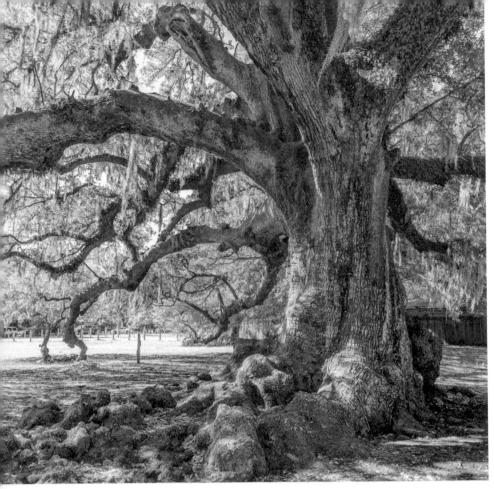

The Tree of Life grows near where sugarcane was first successfully planted and harvested.

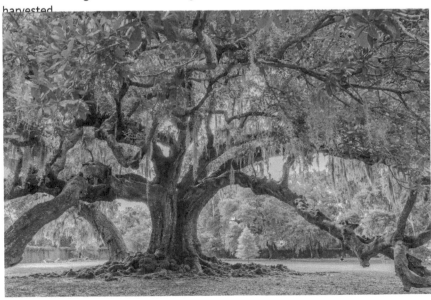

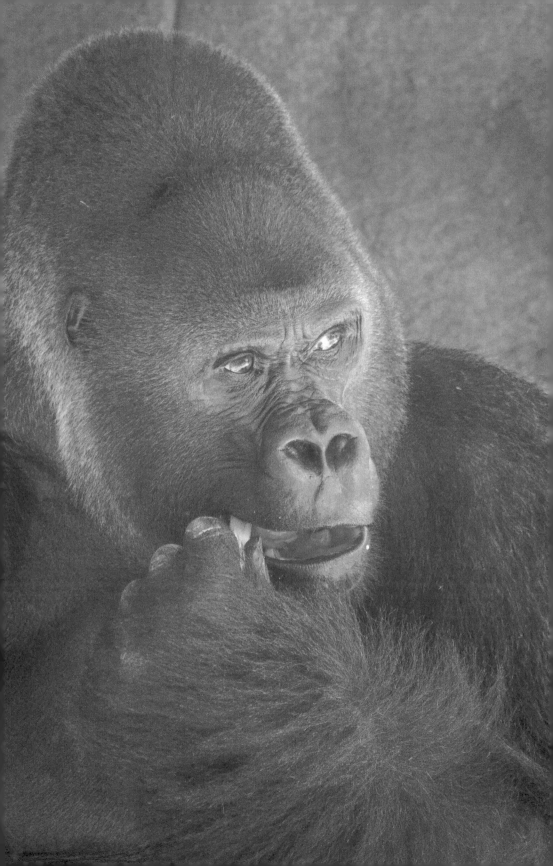

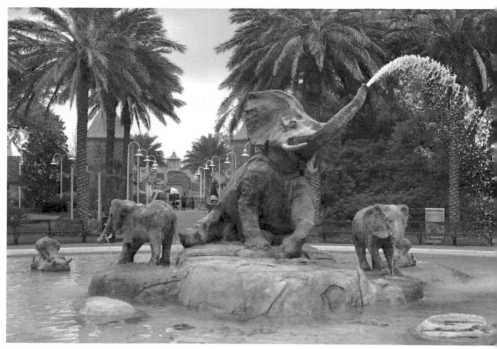

The Audubon Zoo offers an elephant fountain (above) and gorillas (left). To the north is Oak Allée, a double line of live oak trees, planted by Étienne de Boré, whose sugarcane plantation was located here.

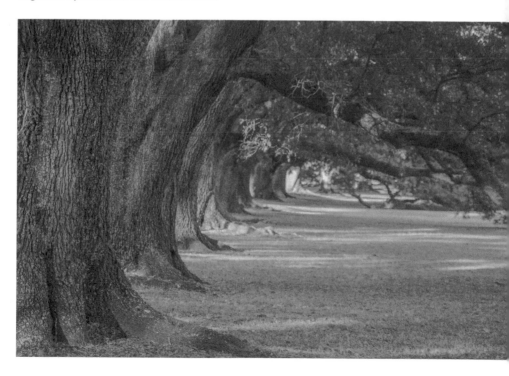

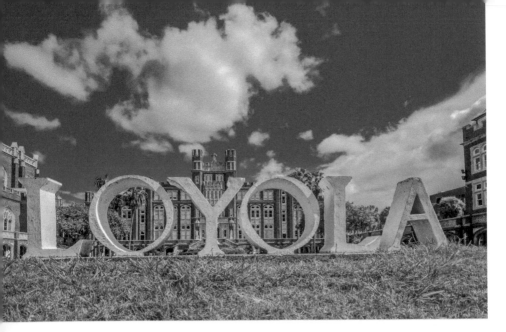

Loyola University New Orleans is a private Jesuit university in New Orleans, established in 1904. It is named for the Jesuit founder, Saint Ignatius of Loyola.

The prominent entrance building is Marquette Hall, for the Jesuit explorer Fr. Jacques Marquette, S.J.

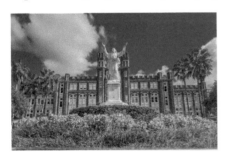

✉ **Addr:**		♀ **Where:**	29.933982
			-90.121778
❷ **What:**	University	◐ **When:**	Afternoon
◉ **Look:**	North-northeast	𝕎 **Wik:**	Loyola_University_New_Orleans

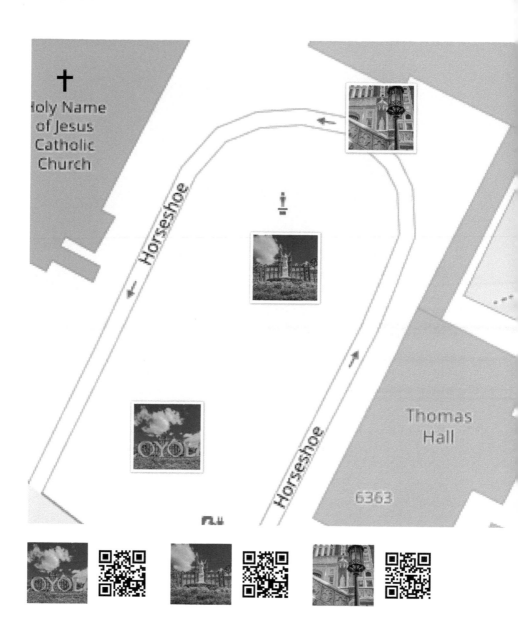

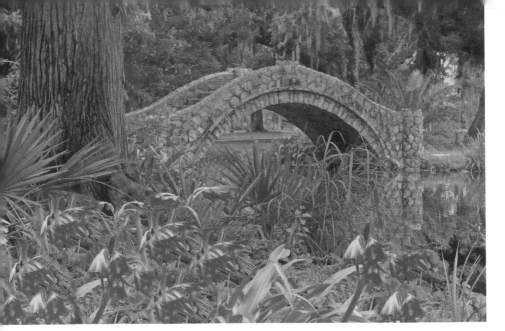

City Park occupies 1,300 acres, about 50% more than New York's Central Park. Photography spots include picturesque Langles Bridge (above); a Ferris wheel at Carousel Gardens Amusement Park (below-left); the Great Hall at New Orleans Museum of Art (NOMA, below-right); and Five Brushstrokes by Roy Lichtenstein outside NOMA (right).

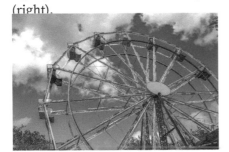

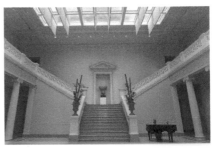

✉ **Addr:**	1001 Harrison Ave, New Orleans LA 70124	♀ **Where:**	29.984857 -90.095634
❓ **What:**	Park	◑ **When:**	Afternoon
👁 **Look:**	East-southeast	W **Wik:**	City_Park_(New_Orleans)

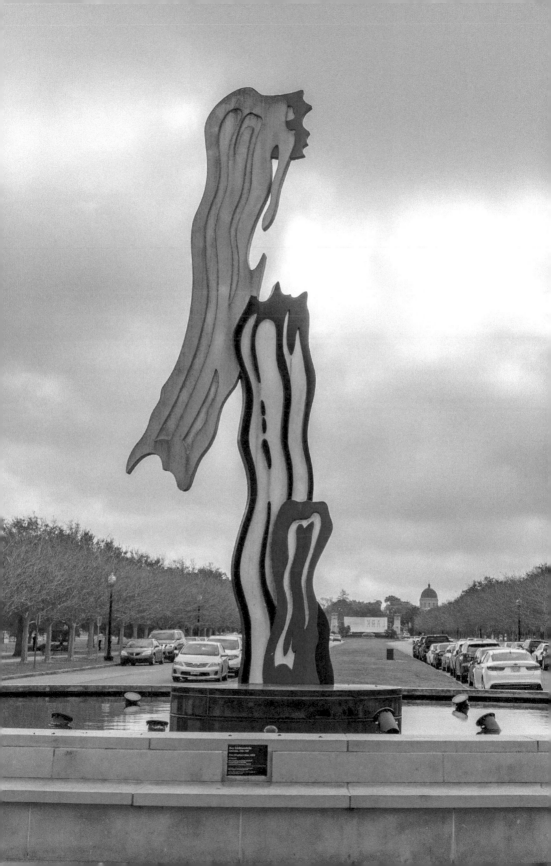

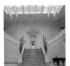

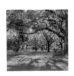

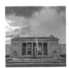

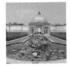

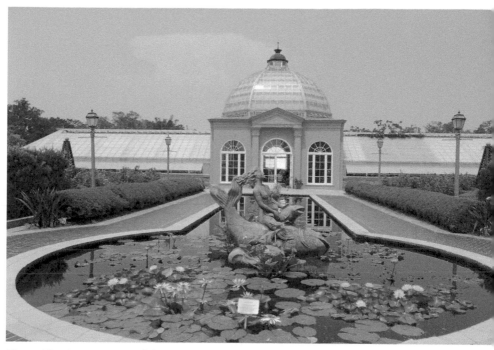

Above: The Conservatory of the Two Sisters at New Orleans Botanical Garden.
Below: City Park holds the world's largest collection of mature live oak trees, some older than 600 years in age.

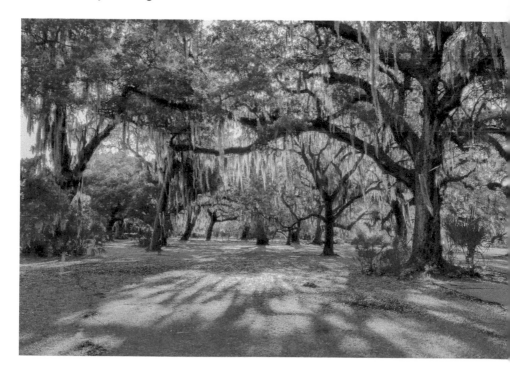

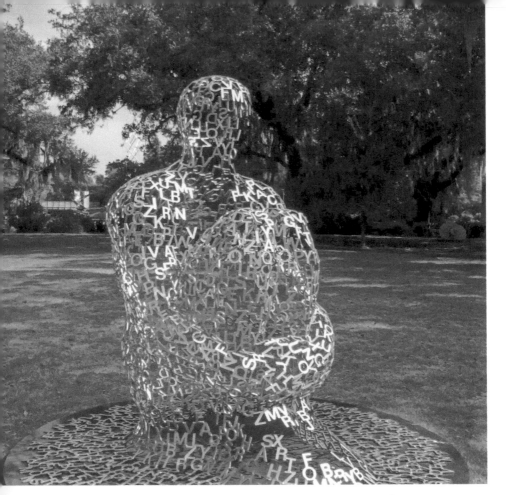

Sydney and Walda Besthoff Sculpture Garden is an 11-acre landscape with 27 sculptures. Part of the New Orleans Museum of Art, you are encourage to walk around and see what catches your eye.

✉ **Addr:**	1 Collins Diboll Cir, New Orleans LA 70124	♀ **Where:**	29.986398 -90.095323
❓ **What:**	Sculpture garden	◐ **When:**	Anytime
👁 **Look:**	Northeast	↔ **Far:**	10 m (33 feet)

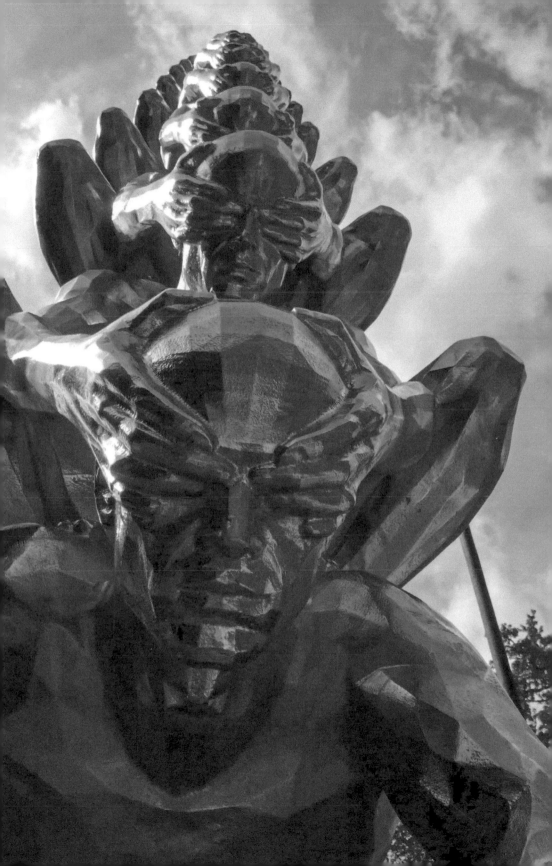

 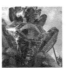

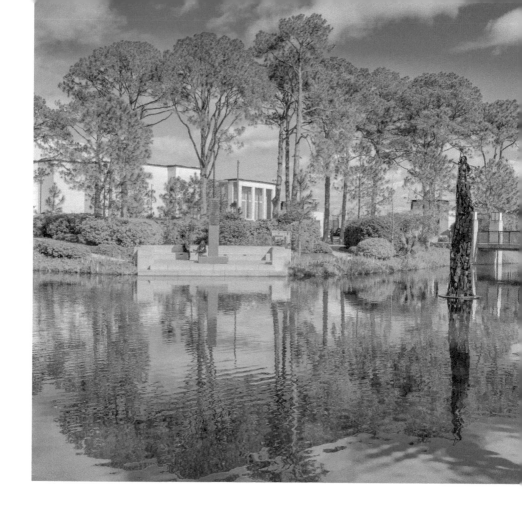

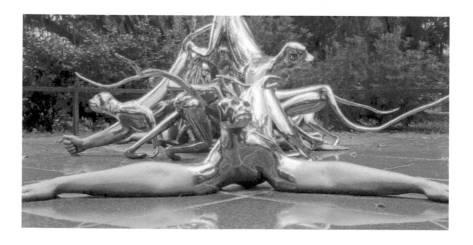

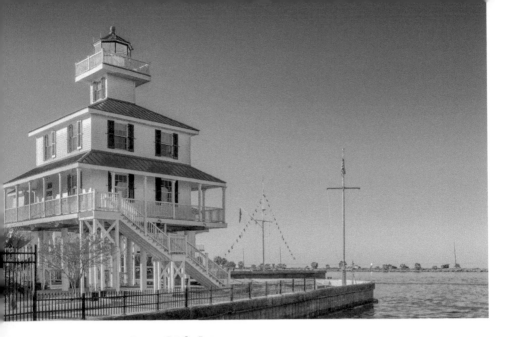

The **New Canal Light** is a scenic lighthouse on Lake Pontchartrain, which you can photograph from near Landry's Seafood House off Lakeshore Drive.

The New Canal (also known as the New Basin Canal and the New Orleans Canal) connected Lake Pontchartrain through swamp land to the booming uptown or "American" section of the city. Opened in 1838, the canal was filled in by about 1950.

The lighthouse dates to 1838 and was replaced and improved, gaining its current form in 1936.

✉ **Addr:**	8001 Lakeshore Dr, New Orleans LA 70124	♀ **Where:**	30.026771 -90.112873
❷ **What:**	Lighthouse	◑ **When:**	Morning
◉ **Look:**	West-northwest	Ⓦ **Wik:**	New_Canal_Light

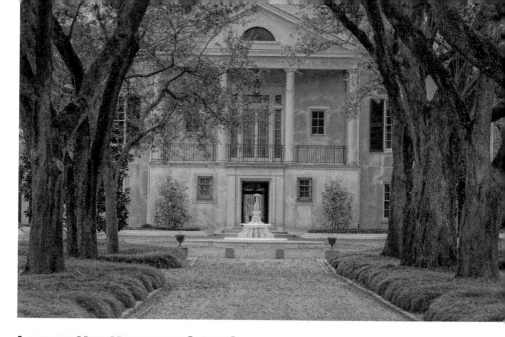

Longue Vue House and Gardens is an historic house museum in the Lakewood neighborhood of New Orleans. Built in 1939, the house connects with different gardens on each side, an example of a Country Place Estate where architecture and the landscape are designed to be interrelated.

✉ **Addr:**	7 Bamboo Rd, New Orleans LA 70124	♀ **Where:**	29.977204 -90.123832
❷ **What:**	Historic house museum	◐ **When:**	Afternoon
👁 **Look:**	East	Ⓦ **Wik:**	Longue_Vue_House_and_Gardens

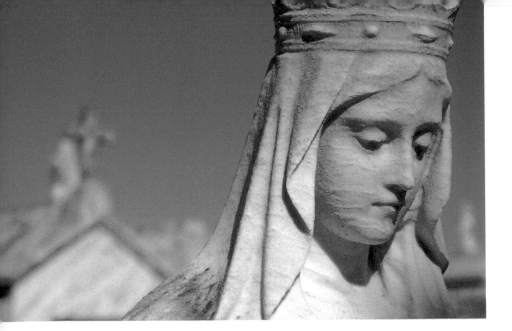

Metairie Cemetery has the largest collection of elaborate marble tombs and funeral statuary in the city.

The site was originally a horse racing track, Metairie Race Course, founded in 1838. When controversial resident Charles T. Howard was refused membership, he vowed that the race course would become a cemetery. After the Civil War, the track went bankrupt and Howard saw his curse come true. He died being thrown from his carriage pulled by a horse, and is buried in the cemetery.

✉ **Addr:**	5100 Pontchartrain Blvd, New Orleans LA 70124	♥ **Where:**	29.98583 -90.11778
❓ **What:**	Cemetery	☾ **When:**	Afternoon
👁 **Look:**	North	W **Wik:**	Metairie_Cemetery

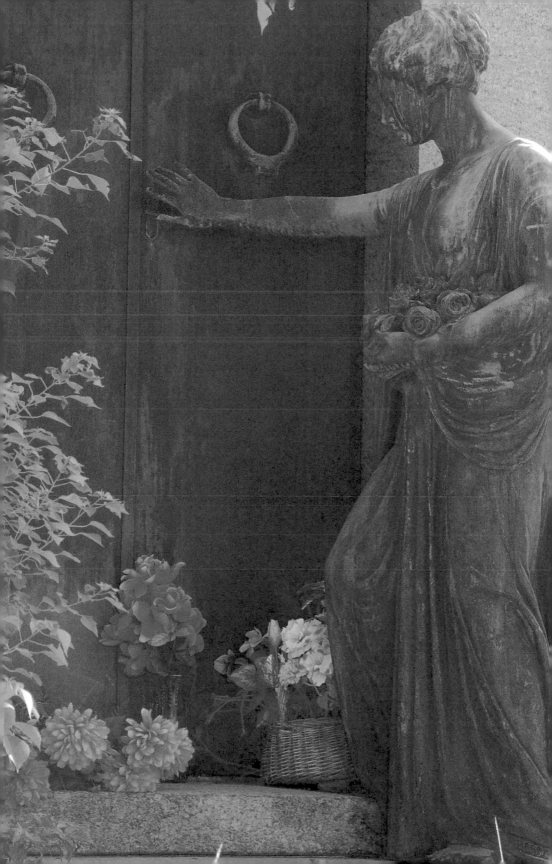

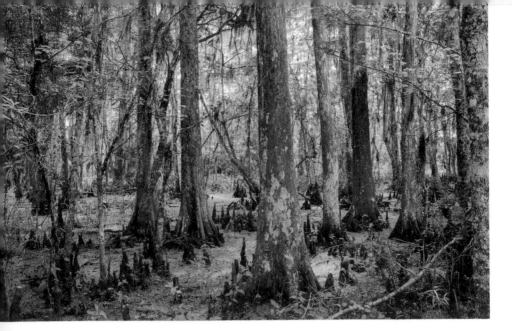

Barataria Preserve is one of the nearest places to photograph a swamp, located about 13 miles (20 km) south of the French Quarter. The preserve's 26,000 acres include bayous, swamps, and marshes, traversed by trails on boardwalks. But beware the alligators!.

✉ **Addr:**	6588 Barataria Blvd, Marrero LA 70072	♀ **Where:**	29.783918 -90.115542
❷ **What:**	Swamp	◑ **When:**	Anytime
👁 **Look:**	North	↔ **Far:**	0 m (0 feet)

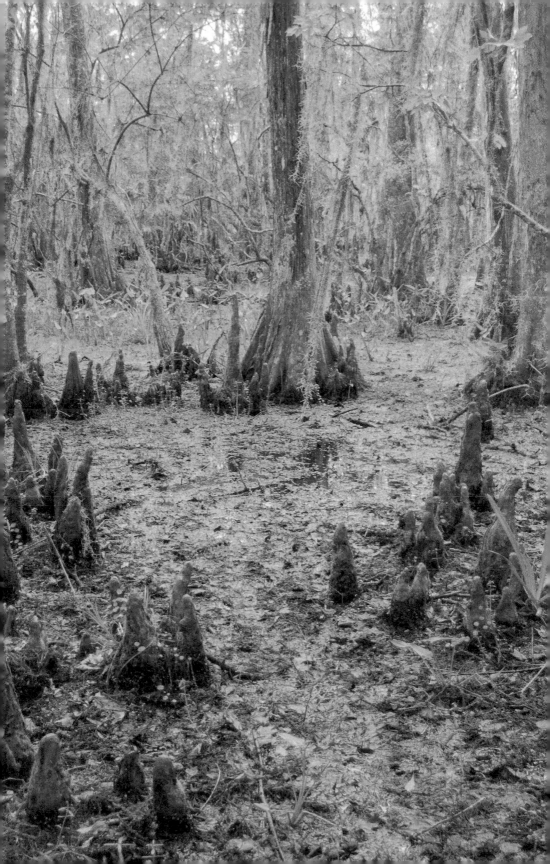

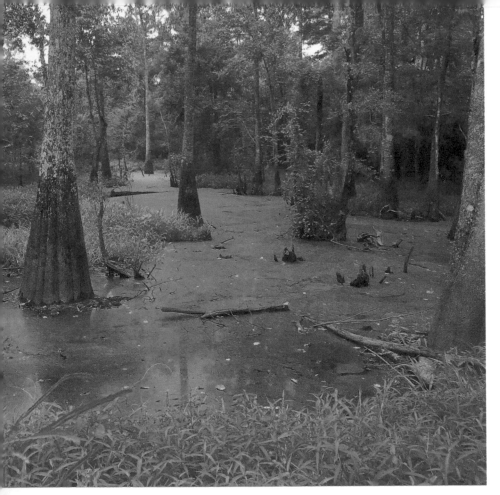

Tickfaw State Park includes a cypress-tupelo swamp and over a mile of boardwalks. The park is about 65 miles drive from New Orleans, toward Baton Rouge.

✉ **Addr:**	27225 Patterson Road, Springfield LA 70462	♀ **Where:**	30.380644 -90.6407302
❓ **What:**	State park	◑ **When:**	Anytime
👁 **Look:**	North-northeast	W **Wik:**	Tickfaw_State_Park

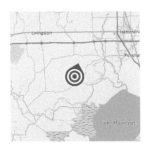 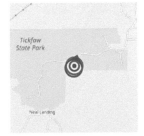

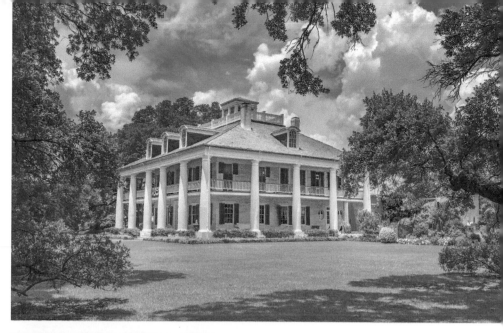

Houmas House Plantation is a 1700s estate with a Greek Revival mansion from 1840. John Burnside from Belfast, Ireland, bought the property in 1857 and grew the operation to about 750 slaves working 12,000 acres, making this the largest slave holding in Louisiana prior to the American Civil War.

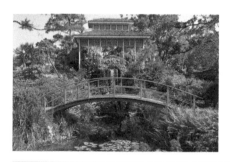

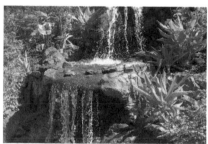

✉ **Addr:**	40136 LA-942, Darrow LA 70725	♀ **Where:**	30.140842 -90.933877	
❓ **What:**	Plantation house	☾ **When:**	Morning	
👁 **Look:**	Northwest	W **Wik:**	The_Houmas	

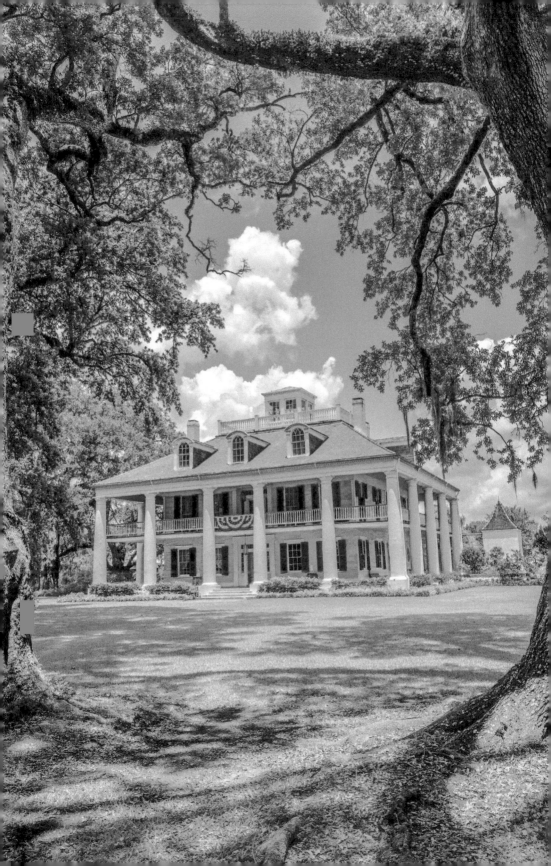

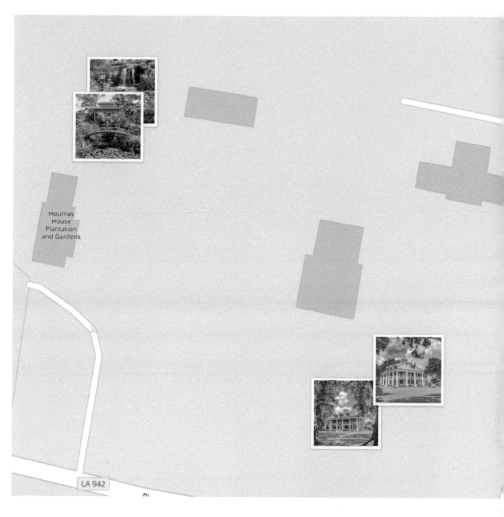

Houmas House Plantation and Gardens

LA 942

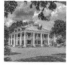 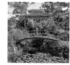 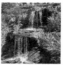

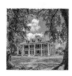

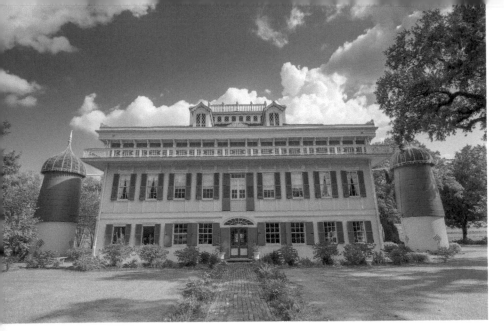

San Francisco Plantation House

San Francisco Plantation House is the most opulent plantation house in the American South. Built around 1855 in a style termed "Steamboat Gothic," the house was so expensive that the inheriting owner declared he was "sans fruscins" (without a penny in my pocket), a name which the next owner changed to "San Francisco."

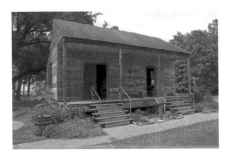

✉ **Addr:**	2776 River Rd E, Garyville LA 70051	♀ **Where:**	30.049740 -90.602077	
❓ **What:**	Plantation house	☽ **When:**	Afternoon	
👁 **Look:**	East-southeast	W **Wik:**	San_Francisco_Plantation_House	

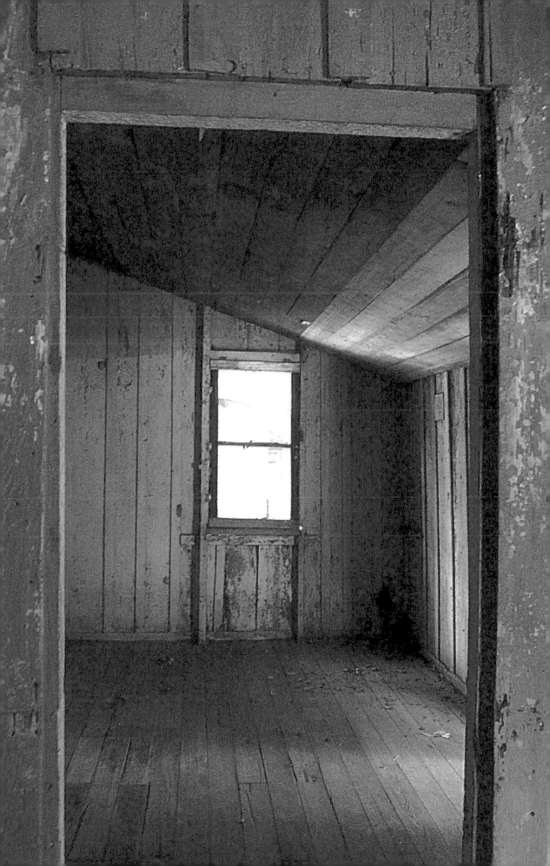

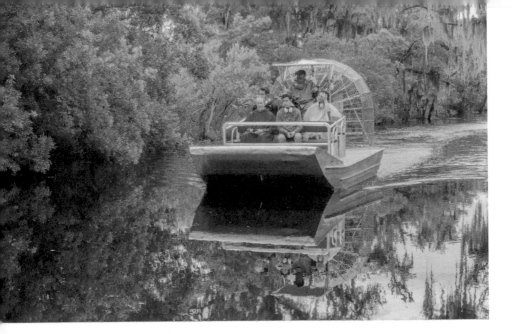

The **Honey Island Swamp** is one of the most pristine swamps in the United States. Located about 40 miles northeast of New Orleans and named for honeybees once seen on a nearby isle, the marshland is over 20 miles (30 km) long and nearly 7 miles (10 km) across.

Tour companies explore different areas, so confirm beforehand that what you want to photograph is covered on your tour.

✉ **Addr:**	Honey Island Swamp, White Kitchen LA 70461	♀ **Where:**	30.21722 −89.649722
◐ **When:**	Afternoon	◉ **Look:**	East
W **Wik:**	Honey_Island_Swamp	↔ **Far:**	0 m (0 feet)

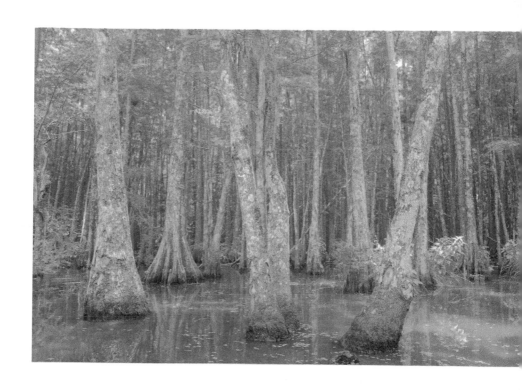

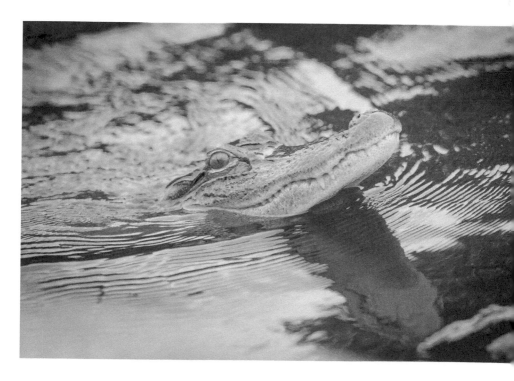

Metro New Orleans > St. Tammany Parish > Honey Island Swamp

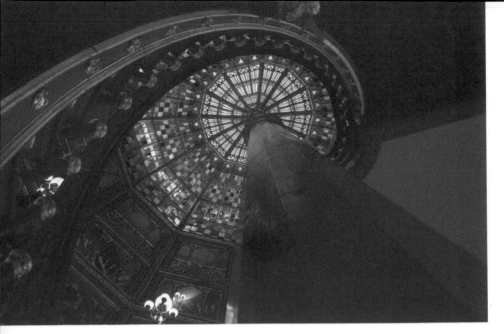

The **Old Louisiana State Capitol** is a castle-like historic government building that is now a museum. Located in Baton Rouge about 85 miles (130 km) northwest of New Orleans, the building stands on a bluff that may have been marked as a Native American council meeting site by a red pole, or *le baton rouge*.

New York architect James H. Dakin, the 1852 building was a Neo-Gothic medieval-style castle overlooking the Mississippi. Following a fire, the statehouse was rebuilt in 1882 by William A. Freret, added a spiral staircase and a stained glass dome.

✉ **Addr:**	100 North Blvd, Baton Rouge LA 70801	♥ **Where:**	30.446574 -91.189712	
❓ **What:**	Museum	◑ **When:**	Afternoon	
👁 **Look:**	East	W **Wik:**	Old_Louisiana_State_Capitol	

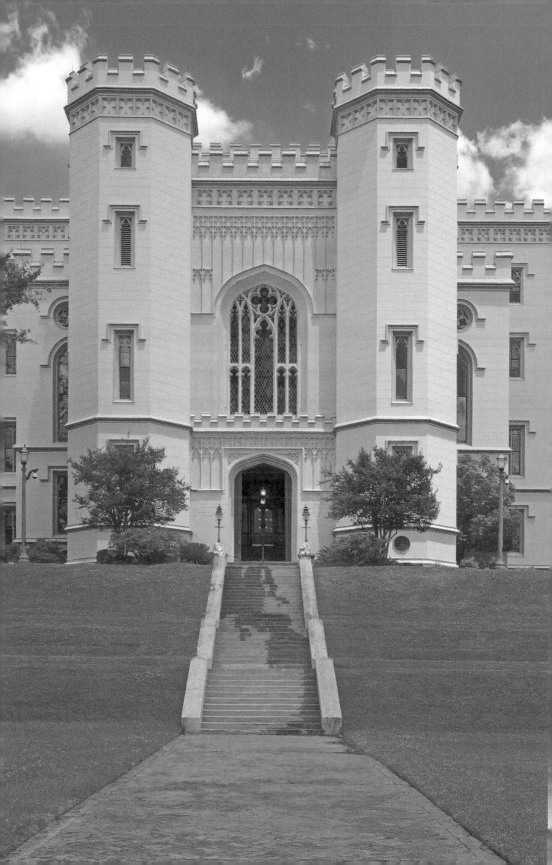

North
Blvd Transit
Hub

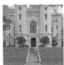

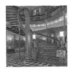

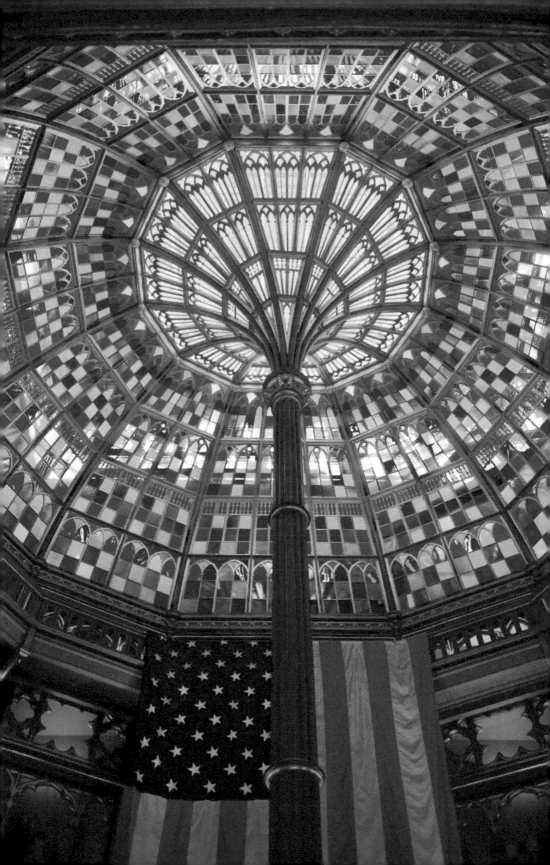

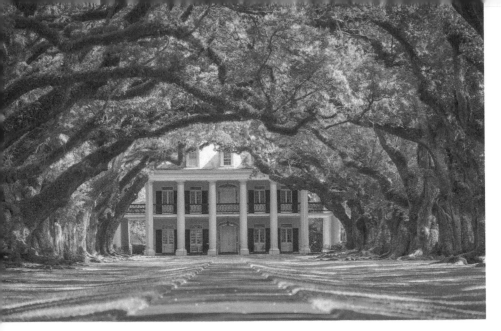

Oak Alley Plantation is named for its distinguishing visual feature, an alley (French allée) or canopied path, created by a double row of southern live oak trees about 800 feet (240 meters) long. Planted in the early 18th century — long before the present house was built — the allée runs between the home and the River.

The classic shot is from the road looking into the property. Use a long lens to compress the perspective and create a deliberately flat, almost abstract, image. A polarizer filter will reduce glare and enhance the green foliage and red pathway.

The Greek Revival mansion has a free-standing colonnade of 28 Doric columns on all four sides that correspond to the 28 oak trees in the alley.

Oak Alley is about 54 miles (86 km) west of New Orleans.

✉ **Addr:**		⚲ **Where:**	30.0068328 -90.7766287
❓ **What:**	Plantation	◐ **When:**	Afternoon
👁 **Look:**	South-southeast	W **Wik:**	Oak_Alley_Plantation

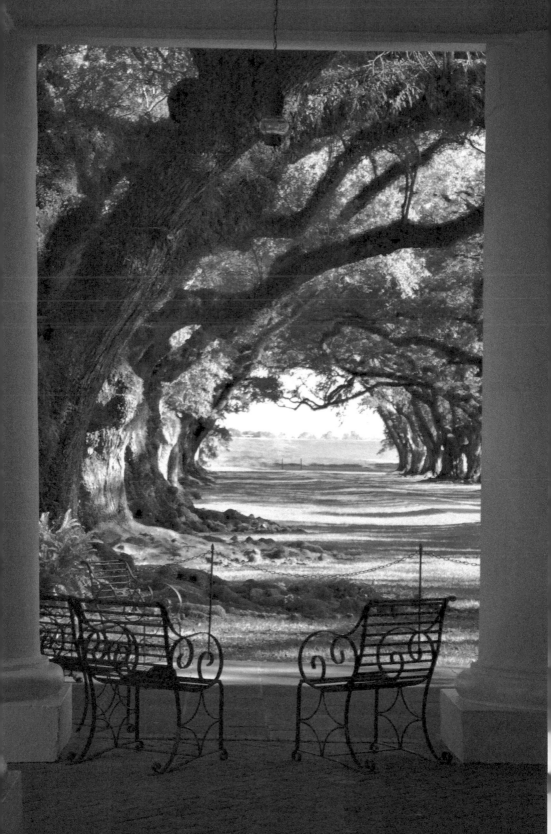

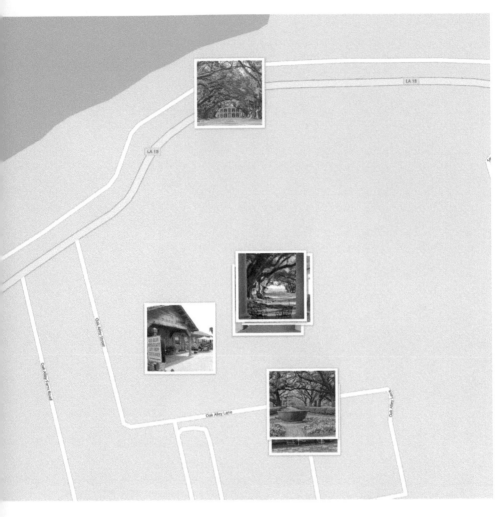

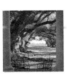

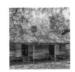

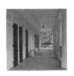

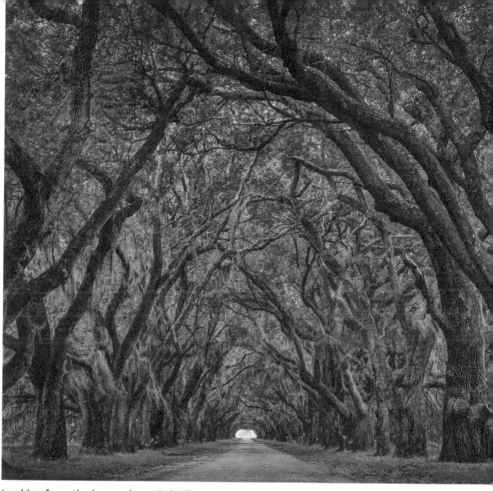

Looking from the house down Oak Alley.

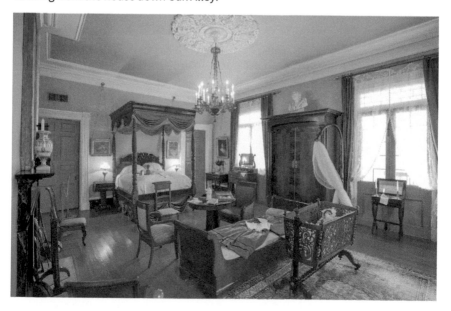

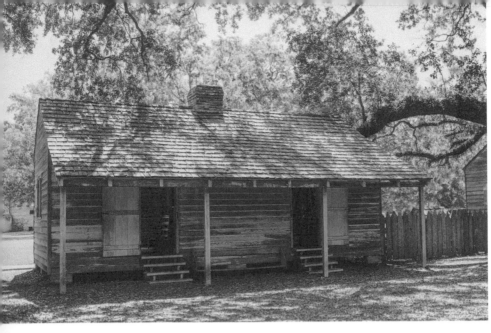

Contrasting a slave hut and the mansion.

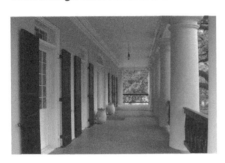
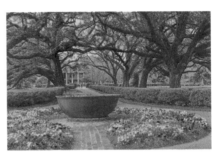

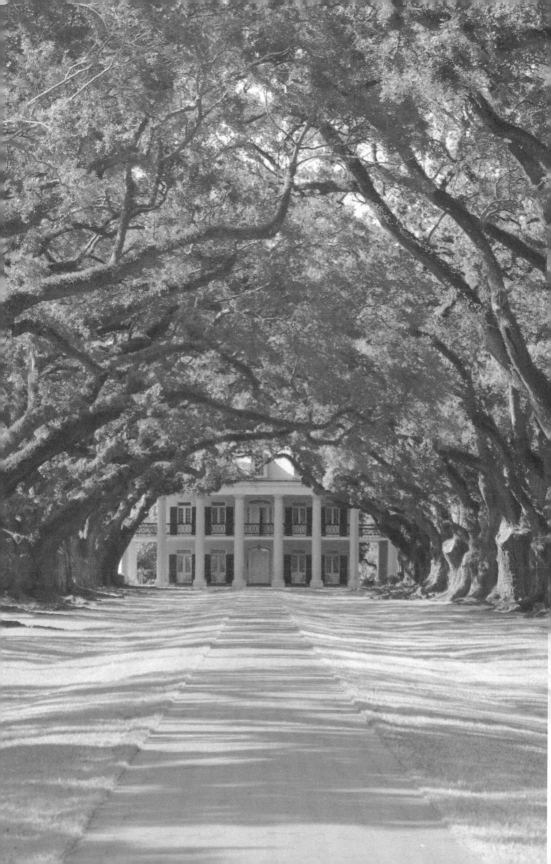

Credits

Thank you to the many wonderful people and companies that made their work available to use in this guide.

Photo key: The number is the page number. The letters reference the position on the page, the distributor and the license. Key: a:CC-BY-SA; b:bottom; c:center; d:CC-BY-ND; f:Flickr; h:Shutterstock standard license; l:public domain; s:Shutterstock; t:top; w:Wikipedia; y:CC-BY.

Cover image by GJGK Photography/Shutterstock. Back cover image by Abbie Warnock-Matthews/Shutterstock. Other images by: 4kclips (33, 98t sh); Alissala (111 sh); Steve Allen (22 sh); Allen.g (45b, 70t, 75b, 77b sh); Amadeustx (28, 67 fd); Corey Balazowich (141 sh); Ruben Martinez Barricarte (66, 105t sh); Nenad Basic (63 fy); Beadmobile (23t sh); Andriy Blokhin (50t, 59t, 72t, 75t, 75, 76t, 86t, 88t sh); Kristi Blokhin (58b, 108t sh); Lori Monahan Borden (27, 126t sh); Brberrys (127 fa); Gary Brownell (37 wa); Chad Carson (111 sh); Ancha Chiangmai (22c sh); Patrick Civello (52t sh); Cls (45t sh); Peek Creative Collective (88c, 88b fy); Paul Comstock (46b sh); Ellie-rose Cousins (57t, 59 sh); Danita Delmont (128 fd); Denisbin (46t fa); Miguel Discart (99, 105, 122 sh); Dndavis (61 sh); Anna Dunlop (143 sh); Evenfh (31t fy); Bart Everson (117b sh); F11photo (20t, 22t, 22b, 24t, 31b, 63t, 69, 81t, 89t, 134t, 142t, 145b sh); Alisa Farov (85t sh); Zack Frank (147 sh); Gagliardi (75 sh); Agnieszka Gaul (73 sh); Gjgk Photography (24, 28t, 48, 49, 112t, 112, 112 sh); Eddie Hernandez (105b fa); Todd Van Hoosear (103t sh); Ecl Images (66 sh); Innapoka (51t sh); Intoit (43 fa); Ironypoisoning (121 sh); Jackanerd (77t, 81b sh); Malachi Jacobs (36t wa); Jami430 (114, 138t fy); Jared (131, 131 sh); Jejim (70b, 94t, 103b, 105 sh); Jfharmon (111b, 128t sh); Wangkun Jia (32 sh); Dane Jorgensen (110 sh); Elliott Cowand Jr (114t wa); Jslon (114 sh); Kathryn Kerekes (71 sh); James Kirkikis (26t, 26, 45, 66t sh); Konoplytska (41t sh); Artemu Kopylovk (47, 72 fy); Brian Lauer (123 sh); Lazyllama (60 fa); Jon Lebkowsky (102t fa); Jill Lee (129 sh); Legacy1995 (98, 101 sh); Candice Legge (111t sh); David Litman (136t sh); Fotoluminate Llc (40t, 40, 57b, 58t sh); Inspired By Maps (41 sh); Nick Martucci (84t fd); Michael Mccarthy (134 fa); Arienne Mccracken (32t fd); Dan Merino (118t, 119, 121b sh); Roberto Michel (130t, 130 wa); Didier Moïse (89 fy); Mark Morgan (24 sh); Kateryna Mostova (126 fy); Nataliemaynor (32 wa); Nolabob (95b sh); Allard One (96 sh); Cody Joseph Painter (63b sh); Kathleen K. Parker (108b, 121t, 125t, 146 sh); Sean Pavone (60t, 63, 96t, 96 sh); Photofires (48t, 65 wl); Hud Photographer (90 sh); All Stock Photos (79, 82t sh); Simply Photos (23b sh); Pisaphotography (78t sh); Oleg Podzorov (55b fy); Prayitno (146 sh); Gts Productions (23, 29, 35, 37t, 40b, 50 fy); Phil Roeder (60 fy); John W. Schulze (135 sh); Shooty Photography (137b sh); Starryvoyage (45, 50 sh); Rirf Stock (107t sh); Page Light Studios (36b, 42t, 115 sh); Cahyadi Sugi (85 fa); Pedro Szekely (23 fy); Reading Tom (117t fd); Louisiana Travel (83t sh); Travelview (38, 53, 55t, 56, 89, 90, 91, 131t, 132 sh); Jaimie Tuchman (114 sh); Ulkare (40 sh); Jim Vallee (138, 139 fa); Vernaccia (146 fd); Vhines200 (25 fy); Vxla (111 sh); Abbie Warnock-matthews (145t sh); Katherine Welles (102 sh); Wkanadpon (95t sh); Frankie Wo (137t sh); Victor Wong (64, 72, 83b, 90t, 93, 124t sh); Zimmytws (106t sh); Diana Zuleta (146t, 146b sh).

Some text adapted from Wikipedia and its contributors, used and modified under Creative Commons Attribution-ShareAlike (CC-BY-SA) license. Map data from OpenStreetMap and its contributors, used under the Open Data Commons Open Database License (ODbL).

This book would not exist without the love and contribution of my wonderful wife, Jennie. Thank you for all your ideas, support and sacrifice to make this a reality. Hello to our terrific kids, Redford and Roxy.

Thanks to the many people who have helped PhotoSecrets along the way, including: Bob Krist, who answered a cold call and wrote the perfect foreword before, with his wife Peggy, becoming good friends; Barry Kohn, my tax accountant; SM Jang and Jay Koo at Doosan, my first printer; Greg Lee at Imago, printer of my coffe-table books; contributors to PHP, WordPress and Stack Exchange; mentors at SCORE San Diego; Janara Bahramzi at USE Credit Union; my bruver Pat and his family Emily, Logan, Jake and Cerys in St. Austell, Cornwall; family and friends in Redditch, Cornwall, Oxford, Bristol, Coventry, Manchester, London, Philadelphia and San Diego.

Thanks to everyone at distributor National Book Network (NBN) for always being enthusiastic, encouraging and professional, including: Jed Lyons, Jason Brockwell, Kalen Landow (marketing guru), Spencer Gale (sales king), Vicki Funk, Karen Mattscheck, Kathy Stine, Mary Lou Black, Omuni Barnes, Ed Lyons, Sheila Burnett, Max Phelps, Jeremy Ghoslin, Les Petriw and Claire D'Ecsery. A special remembrance thanks to Miriam Bass who took the time to visit and sign me to NBN mainly on belief.

The biggest credit goes to you, the reader. Thank you for (hopefully) buying this book and allowing me to do this fun work. I hope you take lots of great photos!

© Copyright

PhotoSecrets New Orleans, first published October 1, 2019. This version output September 9, 2019.

ISBN: 9781930495586. Distributed by National Book Network. To order, call 800-462-6420 or email customercare@nbnbooks.com.

> *"'And what is the use of a book,' thought Alice*
> *'without pictures or conversations?'"*
> *— Alice's Adventures in Wonderland, Lewis Carroll*

© Copyright

🔨 Disclaimer

The information provided within this book is for general informational purposes only. Some information may be inadvertently incorrect, or may be incorrect in the source material, or may have changed since publication, this includes GPS coordinates, addresses, descriptions and photo credits. Use with caution. Do not photograph from roads or other dangerous places or when trespassing, even if GPS coordinates and/or maps indicate so; beware of moving vehicles; obey laws. There are no representations about the completeness or accuracy of any information contained herein. Any use of this book is at your own risk. Enjoy!

✉ Contact

For corrections, please send an email to andrew@photosecrets.com. Instagram: photosecretsguides; Web: www.photosecrets.com

Index

 # More guides from PhotoSecrets